IMAGES
of America

ROCKVILLE

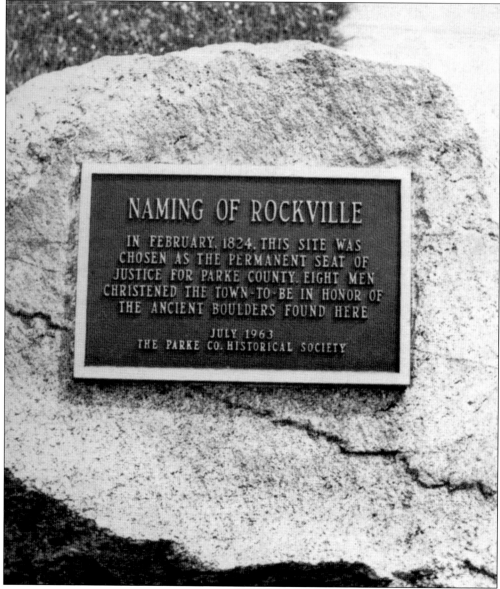

NAMING OF ROCKVILLE PLAQUE, 1963. Early accounts indicate that a large part of the original boulder was used by Persius Harris as the cornerstone for the foundation of the Rockville House, the square's first three-story brick building. The cornerstone was later lost when the building burned in 1873 and the debris was disposed of. (PCHS.)

ON THE COVER: OCEAN TO OCEAN HIGHWAY BOOSTERS, 1915. Spanning the continent from New York City to Los Angeles, the Pikes Peak Ocean to Ocean Highway provided a means of travel when paved roads were rare and travel by automobile was an adventure. Local roads boosters like the one shown in this photograph offered money and road improvements to assure that their town was on the route. (PCHS.)

IMAGES
of America

ROCKVILLE

Blaine Martin for the
Parke County Historical Society

ARCADIA
PUBLISHING

Published by Arcadia Publishing
Charleston, South Carolina

Printed in the United States of America

Library of Congress Control Number: 2010937734

For all general information, please contact Arcadia Publishing:
Telephone 843-853-2070
Fax 843-853-0044
E-mail sales@arcadiapublishing.com
For customer service and orders:
Toll-Free 1-888-313-2665

Visit us on the Internet at www.arcadiapublishing.com

*To Karin Woodson, caretaker of the Parke County Historical
Museum. Her kindness, generosity, patience, and seemingly unending
knowledge of Parke County history made this undertaking possible.*

CONTENTS

ACKNOWLEDGMENTS

I grew up in Rockville during the 1960s and 1970s, living only a block from the courthouse. The picturesque square and the rhythm of small town life became part of my character. The family that I clung to as a youngster has now passed on, as have the neighbors, shopkeepers, and veterans who had such a strong influence on my development. I feel privileged to have been associated with that unique generation. They were a strong group with one foot planted firmly in the past and the other foot cautiously moving into the future. I would like to thank them all for helping me become the person I am today. The small town lessons they taught me—honesty, hard work, integrity, civic pride, love of country, and reverence of history—now live on in my own children.

It has been said the view is clearer when you stand on the shoulders of giants. In the case of this book, nothing could be truer. I would like to thank the early recorders of Parke County history, John H. Beadle, Isaac Strouse, Juliet Snowdon, and countless others both past and present. Without their vision to record so many details and to gather a visual record for posterity, this book certainly would not have been possible.

I would also like to thank the following: my new friends Jane Lyle and Rudy Evans for the contribution of some important photographs from their collections; Lois Norris for her support, suggestions, and encouragement; Mary Jo Harney and her late husband, Richard, for their many years of editing the local history publication *Parke Place*; my dear friend Karin Woodson, for her help, endless knowledge, and boundless enthusiasm for this project; and my late mother, Judy Martin, for instilling in me my endless curiosity and love of the past.

Lastly I would be remiss if I did not thank my dear wife Jeannine, daughter Hayley, and son Shelby, for tolerating my "deep dives" into the past, and supporting my many late nights trying to make this book something we could be proud of. Thank you for your patience and understanding!

The images in this volume appear courtesy of the Parke County Historical Society (PCHS), the author (Martin), Jane Lyle (Lyle), Rudy Evans (Evans), the Library of Congress, Indiana State Library, and the Indiana State Historical Society.

INTRODUCTION

Hewn from the virgin hardwood forests of what is now west-central Indiana, modern-day Rockville began as a collection of widely scattered cabins on the traditional native lands of the Delaware, Pottawatomie, Miami, and Eel River tribes.

According to early Parke County historian Isaac Strouse, the first white settler in Rockville was Aaron Hand, who built a cabin in 1821 in the northeast part of the present town. Andrew Ray came to town in that same year, building a cabin on the northeast corner of the present courthouse lawn. A year later, he brought his family to Rockville and built a tavern on what is now the Rockville National Bank corner. At the same time, Soloman Simmons located a mile southwest of the present courthouse. On February 19, 1824, Gen. Arthur Patterson, Gen. Joseph Orr, and Col. Thomas Smith from the Indiana State Legislature arrived to investigate the site as a permanent seat of justice in the new county. They were met that evening by Andrew Ray, Aaron Hand, James McCall, and several others whose names have been lost to time. The evening was spent in talk and drink at Andrew Ray's tavern.

The following morning, an eight-person group made its way down a short trail to high ground near a large glacial boulder. Nothing could be seen except a thick forest of trees in any direction. Swamps and wetlands lay to the west and south and a deep ravine dominated the east. The group agreed on this site as the location for the new town. Legend has it that Ray insisted he was the area's first settler and the town should be named after him. A lengthy and heated dispute followed with Hand and McCall, both claiming to be the first settlers. Hearing the argument, a bystander stepped forward, putting his hand on the large bolder. He suggested that the rock had been there much longer than any of them, and the town should be named after it. Recognizing the poignancy of the situation, the group agreed. After being christened by breaking an empty whisky bottle on the boulder, the town of Rockville ceremoniously came into existence.

Within a few short years, blacksmiths, tanneries, hatters, cooperages, cabinet and carpenter shops, shoe, harness, and boot makers, and purveyors of general merchandise were calling the new public square home. These buildings were mostly rudimentary wood frame structures, built either connected or very close together. Most were heated with wood or coal and lighted with oil lanterns.

According to one visitor's impressions in 1864, the buildings, then some 30-plus years old, had fallen into decay. The roads were fenced, not graveled, and rutted and muddy. The old brick courthouse was worn and time-stained.

The houses were old and weather-beaten, and the sidewalks were constructed of boards laid down lengthwise and curled up at the ends. The streets were knee deep in mud, and the town contained almost no trees. The north side of the square was composed of mingled brick and wood buildings that were two stories tall and mostly unpainted. Almost all homes had fences around them to keep the free-roaming livestock out of people's yards.

Another early settler remembers that in the 1860s every store in town was closed on Sundays, and all stores had heavy wooden shutters. They were put in front of the windows every night and laboriously taken down every morning. The appearance of the stores on Sunday was gloomy and odd, looking like they had been boarded up and might never reopen again. As a contrast, during special occasions and events, all the windows in the stores and all the courthouse windows were illuminated with rows of candles. Bonfires made of tar barrels and goods boxes lined the streets. Sometimes candlelight processions of hundreds of men on horseback paraded through the streets.

Then, over a period of 13 years beginning in 1870, the face of Rockville was drastically altered when most of the buildings around the square went up in flames, beginning with the north side on the night of September 17, 1870. Then the south side burned on the night of July 4, 1871, soon followed by the east side on the night of December 8, 1871. Less than two years later, in 1873, the Parke House on the west side burned, and in 1882 and 1883 the Opera House and Kelly Block, located northeast of Jefferson and Ohio Streets, burned. The beautiful old National Bank Building, the sole survivor of the 1870 north side fire, was lost in 1906.

The face of the newly resurrected Rockville was quite different. As the rebuilding of the square occurred over the next few years, an exceptional example of small town Italianate architecture emerged, much different from its haphazard Colonial style predecessor. Three-story brick and stone buildings replaced two-story wood frame structures. Concrete sidewalks replaced wood and brick walkways. Canvas awnings, ornate cornice designs, and large architectural iron and glass storefronts became the standard. It was during these years that Rockville began to visually resemble the quintessential small town that is treasured and protected today.

Over the next century the town flourished into a hub of agriculture, commerce, and government for the county. Electricity was introduced. Roads were paved. The automobile replaced horses and buggies. But, in its essence, the town remained the same. It was still a vital rural center of country and farming life.

Then, after World War II, the face of Rockville gradually changed again. Like thousands of other rural centers of life around the country, this change was brought on by progress. Life was evolving. Younger citizens were drawn away by education and the promise of a brighter future, and many of them did not return home. Travel was no longer an impediment. Shoppers slowly began bypassing local mom-and-pop stores for chain stores in larger areas.

By the 1970s, the change had begun in earnest, and by the turn of the century it was complete. A larger world had become accessible, and the clothing stores, shoe stores, grocery stores, and restaurants that had enlivened Rockville's public square for more than a century were disappearing. Tourism became a primary driver of the local economy and Rockville was now a destination for those interested in a glimpse of how life used to be.

Now, paradoxically, the very key to Rockville's future lies in the preservation of its past. Thankfully, a strong legacy of preservation already exists within the community. It is hoped that the photographs and facts collected in this book will help foster a continued respect for that legacy. Rockville needs the next generation's leadership and active involvement as it moves forward into an uncertain future.

Please note that this book is by no means a definitive history of the town. It is merely a romantic snapshot of an early and vibrant period in our collective history that has now passed. It is a collection of moments frozen in time. A wonderful mix of places and people who lived, loved, worked, played, and prospered in a small Indiana town called Rockville.

One

A Town is Born

Rockville in the Beginning, 1823–1870

The public square had its beginnings in 1823 with a double log house, known as Ray's Tavern, on the northwest corner of the square where the Rockville National Bank now stands. At the time, the closest neighbor was nearly a mile away. Although Aaron Hand is generally thought to have been the first settler in the town proper, Andrew Ray is considered by many to be the father of the town because of his home and tavern's central location and because of his donation of the first 60 acres to form the new town. Another donation of 20 acres from Hand and 20 acres from James McCall formed the original 100-acre tract of land that became early Rockville.

At that time, the area was complete wilderness. One could look in all directions and see nothing but untouched primitive lands. Wetlands and swamps were to the east in the Little Raccoon Valley. Virgin forests were found to the north toward Sugar Creek and to the east stretching toward the Wabash River. Rolling hills, forests, and steep ravines broke the land to the south. A natural spring and large rattlesnake den was located a little more than a block south of today's square. Native Americans still could be found roaming their native hunting grounds. The land had remained much the same since the Ice Age. But that was all about to change.

Rockville was about to transform itself from a raw frontier outpost into a pioneer settlement and seat of justice for the new county. Over the next few years the fledgling town flourished as a regional hub of agriculture, commerce, entertainment, politics, and government. A rudimentary log courthouse was soon completed, which was replaced by a brick structure in 1829, followed by the building of primitive one- and two-story wood frame homes and commercial structures around the square.

These pioneer businessmen, lawyers, farmers, and landholders were to play an important part in the future of the burgeoning young town and in the development of the state.

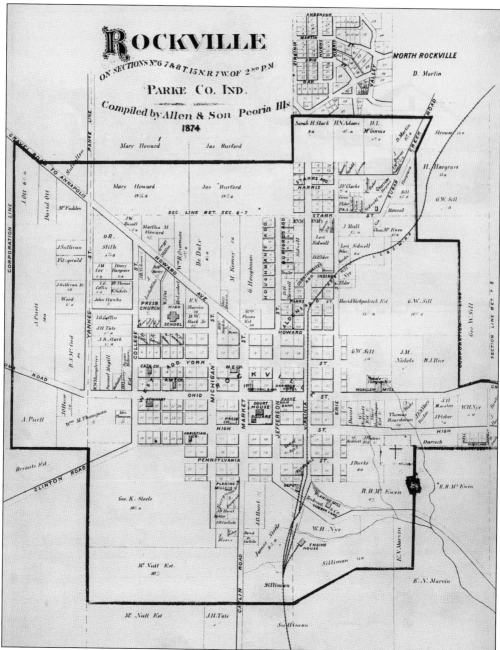

EARLY MAP OF ROCKVILLE, 1874. One of the earliest maps of Rockville, this drawing dates from when the town was 50 years old. The old courthouse is shown in the center, along with the clerk's office where the early town records were kept. This building was later lost to fire. Toward the bottom center is the original roadbed of the Evansville and Crawfordsville Railroad coming in from the south and running up Virginia Street. To the west of town on Ohio Street is the old flour mill and mill pond. Yankee Street and Clinton Road eventually became U.S. Route 41, and Ohio Street became U.S. Route 36. The old fairgrounds and Puett's Grove were located just to the west of Yankee Street. (Martin.)

NAMING OF ROCKVILLE WOODCUT, 1916. This woodcut, taken from the front of the August 12, 1916, Parke County Centennial Pageant program depicts the naming of Rockville. Early settlers Andrew Ray, Aaron Hand, and James McCall gathered with three Indiana commissioners and bystanders on the present courthouse lawn. After a heated debate about naming the town after one of the three early settlers, a compromise was reached. The new town was named Rockville by ceremoniously breaking a whiskey bottle over one of the many large boulders present. (Martin.)

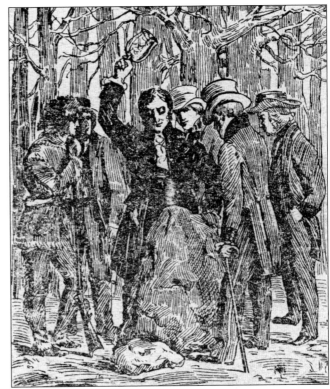

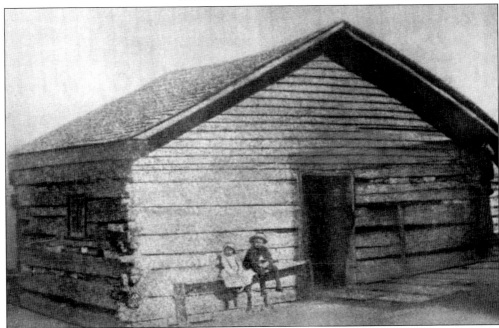

LOG SCHOOLHOUSE, C. 1860. This primitive log structure was built in 1825, replacing the first Rockville school, which was a simple lean-to structure. The floor of the first building can be seen extending from under the front wall on the right. The schoolhouse was also used as a meeting hall for the young town and as a local debating society until 1836. (PCHS.)

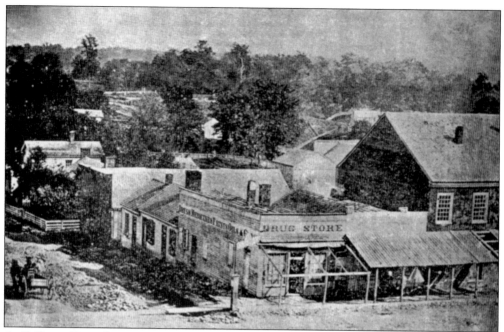

A. C. Bates Drug Store, c. 1869. This photograph of the northeast corner of the square is one of the earliest known views of Rockville's early downtown area. A. C. Bates came to Rockville in 1861 and established the drugstore shown above. Francis Whipple owned the dry goods store to the right. Thomas Bogus and Son Hatters occupied the building behind the drugstore. (PCHS.)

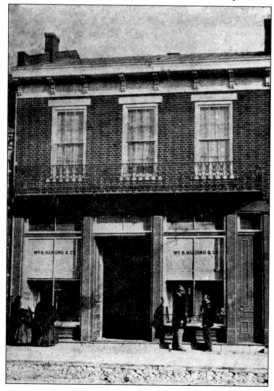

W. H. Harding and Company, 1870. W. H. Harding was an associate of Greenbury Ward, one of the town's first settlers. His dry goods store was located near the middle of the east side of the public square. At about 10:30 p.m. on Friday night, December 8, 1871, the store was discovered in flames. The culprit was thought to be an oil lamp. Despite a gallant firefighting effort on behalf of the bucket brigades, most of the east side was lost. (PCHS.)

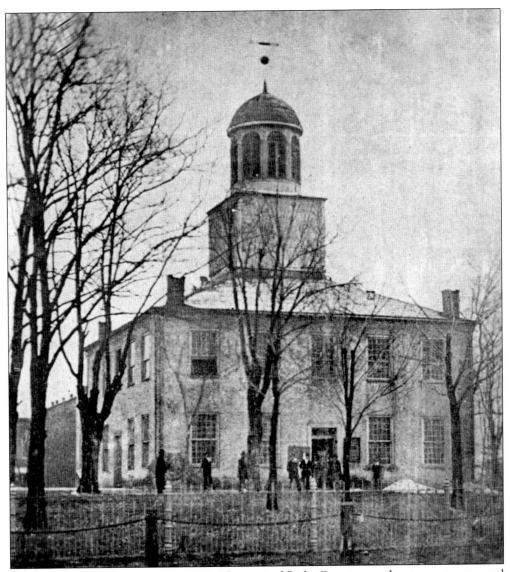

First Permanent Courthouse, 1879. The original Parke County courthouse was constructed in 1829 of brick. It measured 60 feet on each side and was considered quite imposing for its time. It replaced a temporary log structure built in 1826 on the same site. The cupola was enclosed by green shutters and was topped with a large copper ball and spear-shaped weather vane. The weather vane was 6 feet long and stood exactly 70 feet above the ground. In 1863, a separate four-room brick building called the "clerk's office" was built on the southwest corner of the courthouse lawn to keep the county records safe from fire. This photograph is from the day in 1879 that demolition began. (PCHS.)

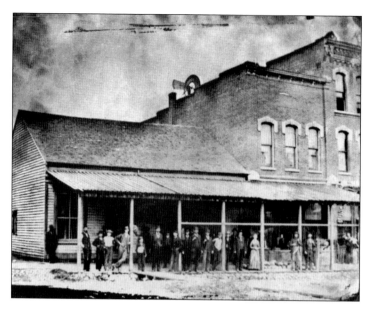

H. G. Hungerford Dry Goods Exterior, c. 1885. The H. G. Hungerford Dry Goods and General Merchandise Store was located on the west side of the square. It is the two-story brick building. At that time there was an alley running east and west at the center of the block. This store was located just north of that alley. Tona's Cigar Store was located in the frame building to the left and the Parke Hotel was to the right. (PCHS.)

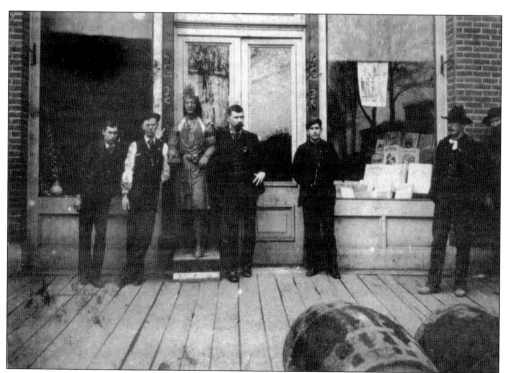

Tona Lundgren's Wooden Indian, c. 1890. Tona Lundgren (third from left), owner of Tona's Cigar Store, posed with his advertising trade figure in front of the H. G. Hungerford Store. Youngsters found amusement in placing the figure in front of different businesses. This caused Tona to leave his store, locate the figure, and return it to its rightful place outside his store entrance. Tona acquired the statue in 1885 and it stood proudly in front of his store until July 4, 1897, when an overzealous prankster sadly blew the figure's head off with a large firecracker. (PCHS.)

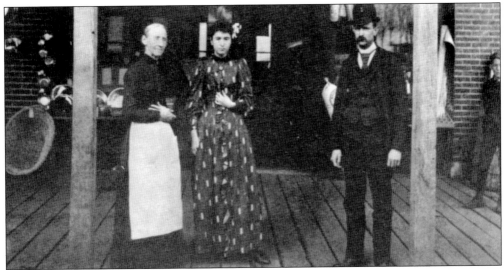

IN FRONT OF HUNGERFORD'S, C. 1885. Jane Hungerford, Julia Leonard, and Tona Lundgren pose for a photograph in front of H. G. Hungerford Dry Goods Store. Notice the wooden walkway in front of the store. In the 1870s, the town passed an ordinance that in the built-up parts of town all sidewalks had to be constructed of oak planks eight inches wide and six feet long. By the 1890s the oak sidewalks had been replaced by bricks and then concrete. (PCHS.)

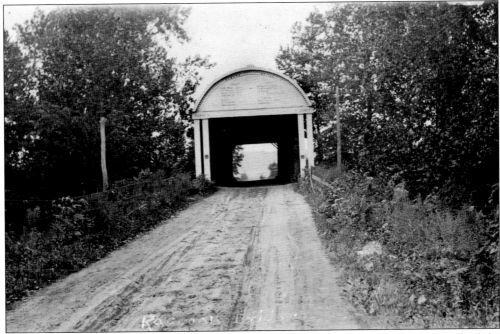

HOWARD BRIDGE, C. 1909. This unique round-topped Burr Arch covered bridge was built by Henry Woolf in 1859. It crossed Little Raccoon Creek 3 miles east of Rockville at the site of the old plank road. It remained in use until 1913, when it was destroyed by flood waters. It was replaced by another covered bridge built by Joseph A. Britton. (Martin.)

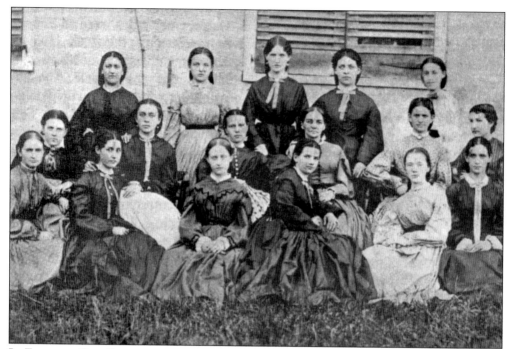

IN FRONT OF OLD COURTHOUSE, C. 1865. Although the purpose of this group of distinguished young ladies is unknown, the photograph's significance lies in the fact that this is one of the only known close-up views of the old courthouse's exterior. Note the cracks visible in the exterior wall and the disrepair of the shutters. At the time of the photograph, the building was only 36 years old. (PCHS.)

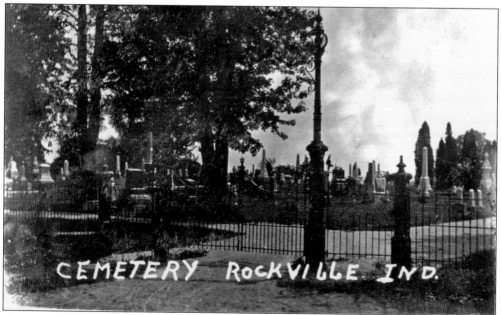

ROCKVILLE CEMETERY, C. 1900. Many of the town's early citizens are interned in the Rockville Cemetery, located north of town on the east side of High Street near the train depot. It has changed very little in the past century and a half. (Martin.)

Two

A Town Grows Up

Rockville at Work, 1871–1945

Over a period of 13 years, beginning in 1871, Rockville's original pre–Civil War town square of fragile, wood-frame buildings was consumed by fire. Fine brick and stone examples of Italianate architecture, a style that was being adopted by many small towns throughout the Midwest, soon replaced those structures. In 1879, the cornerstone was laid for a magnificent new courthouse. The face of the town was altered dramatically.

During the closing decades of the 19th century, the town square was the center of rural life. It was where people purchased items they couldn't make or grow themselves. It was where people caught up on important news, gossiped, mailed letters, and stocked provisions.

Roads were made of dirt or gravel, and they were rutted and muddy in the winter and dry and dusty in the summer. Most people never ventured farther than the nearest town, usually less than a half day's ride away. Communication was mostly via word of mouth, the newspaper, telegraph, or information brought in by the railroad. Hand-painted signboards and large figural trade symbols in the form of locks, boots, watches, and razors appeared on the outside of the buildings. Canvas awnings, many adorned with the store owner's name, dominated the street scene. Horse-drawn buggies and wagons were tied to the hitching posts surrounding the courthouse lawn. Things were still very similar to the way they had been nearly a century earlier.

Then, by the dawn of the 20th century, the world was beginning to change. Electricity was introduced in 1891. Running water was introduced in 1909. Roads were improved. Wooden plank and brick sidewalks were replaced by concrete walkways. Horse travel began its decline with the appearance of the automobile in 1908. Recessions, depressions, and world wars came and went. The radio, the telephone, and other technologies were introduced. The world was becoming smaller, but still, by the onset of World War II, the overall essence and character of Rockville had changed very little.

This chapter attempts to capture that wonderful period of time before distant travel, instant communication, and the demise of locally owned businesses forced many small towns to the edge of extinction.

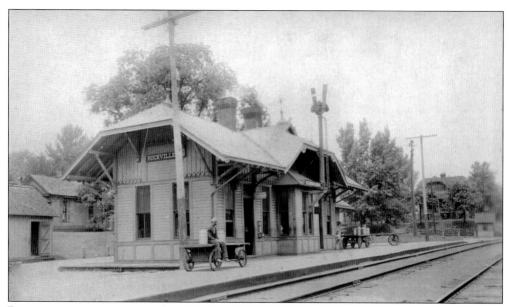

ROCKVILLE DEPOT, C. 1910. The first train of the Evansville and Crawfordsville Railroad pulled into Rockville on Thursday, December 4, 1860, on a roadbed that was built between Terre Haute and Rockville. At that time, Rockville was the northern terminus for the railroad. The Logansport, Crawfordsville and Southwest Railroad was completed in 1871, linking the line to other railroads in the north. In 1881 the line sold to the Vandalia Company, which built this depot east of town in 1883. (Martin.)

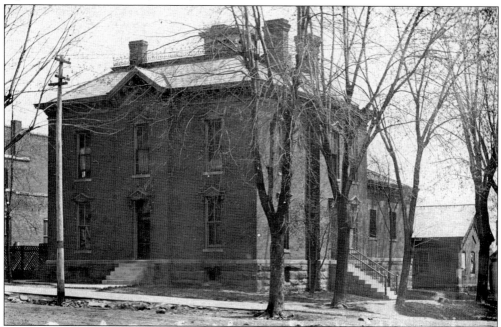

JAIL AND SHERIFF'S RESIDENCE, C. 1900. The sheriff's residence was designed and built at the same time as the courthouse. A boiler building was located behind the residence with a tunnel running to the courthouse to provide steam for heat. The previous residence and jail, built in 1832, still stands at the corner of High and Virginia Streets one block to the east. (PCHS.)

NORTH SIDE VIEW OF COURTHOUSE, C. 1900. The courthouse was designed by architect T. J. Tolan and Son of Fort Wayne, Indiana in 1879. Representing the ornate Second Empire style, it was originally planned to be constructed of red brick trimmed with limestone. This was soon changed and the red brick was substituted with Indiana limestone atop a native sandstone foundation. This photograph shows in detail the decorative iron cresting around the mansard roofs and the numerous finials protruding from the roof's corners. Unfortunately these wonderful architectural details have been lost over time and are no longer present on the current courthouse. (Evans.)

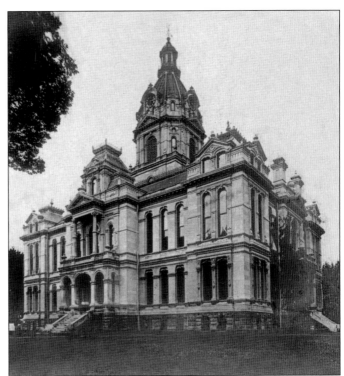

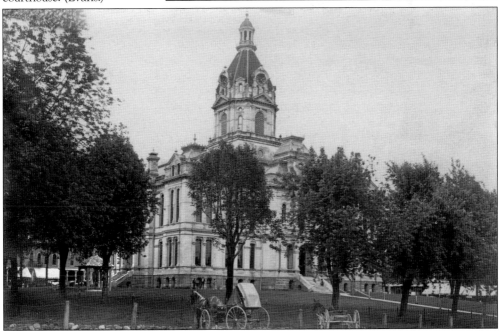

SOUTHWEST CORNER OF THE COURTHOUSE, 1906. Two years after this photograph, the weather vane atop the courthouse fell and broke through the roof. The spear and directional pointers were badly bent. The weather vane was soon repaired, once again allowing the spear to swing freely in the wind. It was an important visual indicator to local fishermen, who used the wind direction to determine when the fish would bite. (Martin.)

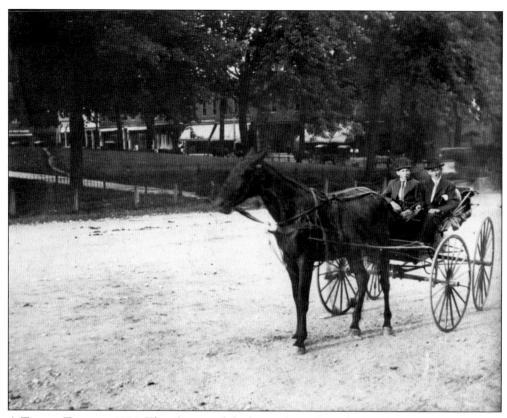

A Trip to Town, c. 1900. This photograph looks northeast from the freshly graveled High Street on the south side of the courthouse. The hitching posts, chain, and the ornamental iron fence that surround the courthouse lawn are shown here in nice detail. The east side of the square is in the background. The sheriff's residence is out of the frame to the right. (PCHS.)

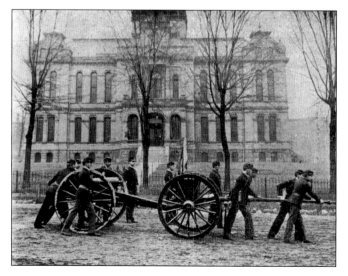

Rockville Light Artillery, 1893. After the Civil War began to fade from memory, a new generation of young people wanted to show their patriotism by forming home guard units. Many towns had units such as these, which competed against each other in competitions. The McClune Cadets were formed in Rockville in 1880, followed by the First Rockville Battery in 1883 and then the light artillery unit, shown here, in 1887. (PCHS.)

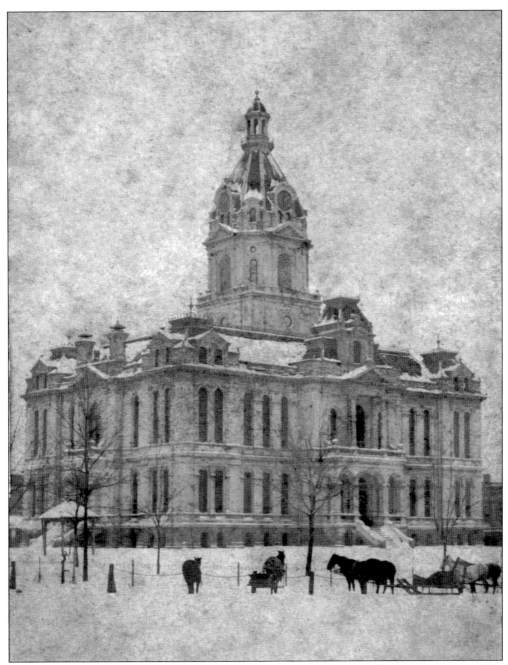

WINTER SCENE OF COURTHOUSE, C. 1898. The local Masonic lodge laid the cornerstone of the courthouse on September 11, 1879. A tin box with mementos from the period was placed inside the hollowed-out stone. Grand Master Robert Valzah exclaimed, "May centuries elapse ere the tokens herein deposited see the light of day." On February 22, 1882, dedication ceremonies were held to the accompaniment of an orchestra from Indianapolis and speeches by state dignitaries. A candlelight dance was also held that evening in the marble corridors of the building. The gas lamps that helped light the night still stand on the newel posts of the first floor stairway, though they have since been converted to electric lamps. (Indiana State Library.)

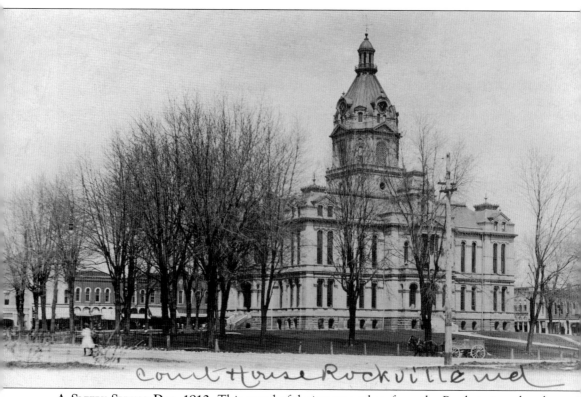

court House Rockville md

A Sleepy Spring Day, 1912. This wonderful view was taken from the Presbyterian church corner (also known as Steele's Corner), looking northeast. The little girl appears to be playing while her family does business in town. At this time the great bell atop the courthouse had to be rung manually. It was only heard before sessions of court and for the funeral of a member of the local bar. Since it was electrified in the 1940s, the bells ring every hour on the hour and can be heard for miles. (Evans.)

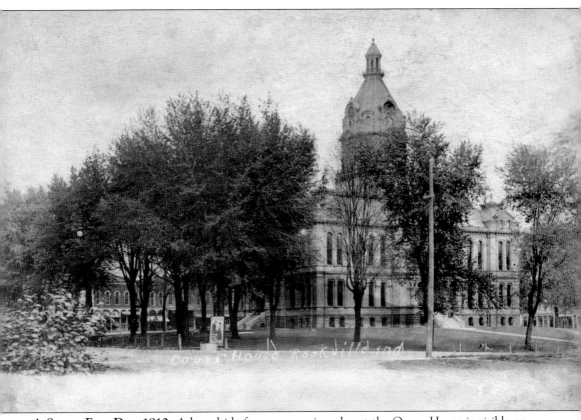

A Sleepy Fall Day, 1912. A broadside for an upcoming play at the Opera House is visible on the corner beside the watering trough. The ornamental iron fence (in place on the opposite page) was removed in September 1912, but the hitching posts still remain. They too soon disappeared, post-by-post beginning with the north side, around 1920 as the automobile became the preferred mode of transportation. (Martin.)

LOOKING EAST FROM THE PARKE HOTEL CORNER, 1930. From group photographs and human flies to today's Covered Bridge Festival, the courthouse lawn has been the site of many events. According to one early newspaper account, a hot air balloon ascension was said to have went awry when the pilot, launching from the vacant lot next to the newspaper office, lost control of the vehicle and landed in a treetop on the courthouse lawn, barely missing getting caught on the weather vane. (Martin.)

LOOKING SOUTHEAST TOWARD THE COURTHOUSE, C. 1934. Local legend has it that Fred Calvert was one of the first automobile owners in the county. He claimed his 1909 Buick automobile could do nearly anything. To the amazement of onlookers and skeptics, he drove the small car up the north steps of the courthouse, through the marble corridor, made a right turn, and went down the west steps. (Martin.)

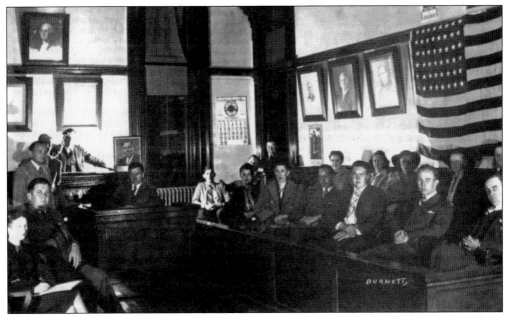

YOUNG REPUBLICANS MOCK TRIAL, 1940. Young Republicans gather in the courtroom of the courthouse to hold a mock trial for Pres. Roosevelt's New Deal. With Republicans viewing the program as an enemy of business and growth, it came as no surprise the program was convicted. The role of the New Deal in America's recovery from the Great Depression still remains a source of controversy and debate among economists and historians. (PCHS.)

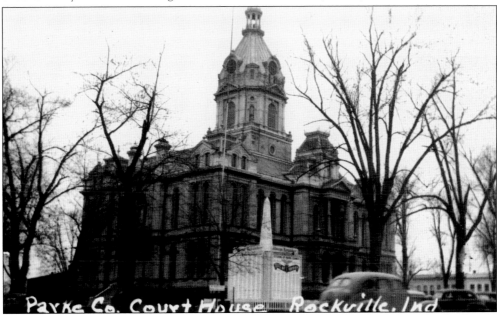

WORLD WAR II ROLL OF HONOR, 1944. On July 11, 1944, a little more than a month after D-Day, a memorial inscribed with names of all Parke County citizens serving in the armed forces was dedicated. Seated at the platform during the dedication were representatives from the Civil War, World War I, and World War II. The memorial was located on the northeast corner of the courthouse lawn. (Martin.)

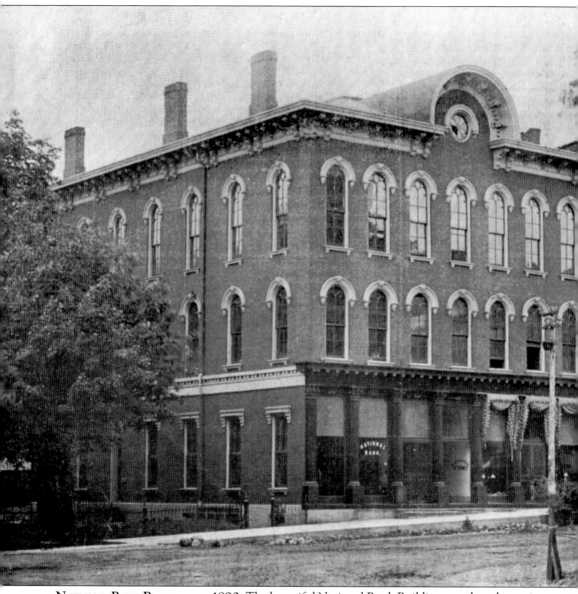

NATIONAL BANK BUILDING, C. 1890. The beautiful National Bank Building was the sole survivor of the 1870 north side fire. It was completed in 1869 despite much criticism concerning the expense of constructing such a magnificent building in a small town. Old National Hall was located on the top floor and quickly became the center of the town's culture. It had a large stage with wings, dressing rooms, and a large stage curtain ornamented with a lavish painting of snowcapped peaks, a castle, and a lake. Plays, dances, and festivals in the old hall were highly attended and fondly remembered. Sadly, the building was lost to fire in 1906. (PCHS.)

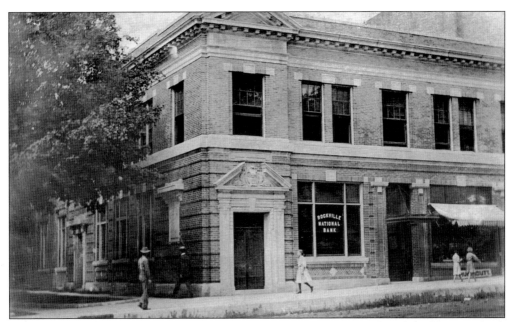

New National Bank Building, c. 1908. The new Rockville National Bank building was built in 1907 after the magnificent old National Bank Building was lost to fire on November 16, 1906. Hunnicutt, the town's jeweler and optician, occupied the storefront with the awning. The National Bank was robbed by John Dillinger on July 19, 1933. He escaped northward on Howard Avenue, spreading roofing nails behind his car. The noontime robbery garnered only $140. (Martin.)

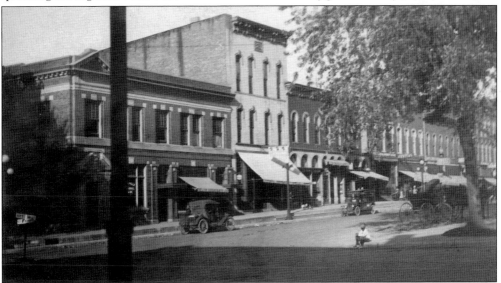

North Side of Square from Parke Hotel Corner, c.1920. From local newspaper accounts, it appears that 1910 was the turning point when citizens began to move away from the horse and buggy and embrace the automobile. In January 1910 there were approximately 25 motorized vehicles in Rockville; by June 1910, the number had swelled to 41. At that time, less than 2.5 percent of America's families owned an automobile; by 1920, that number had grown to 10 percent. Ten years later, more than half of America's citizens owned a car. This photograph of the north side documents that transitional period. (Indiana State Historical Society.)

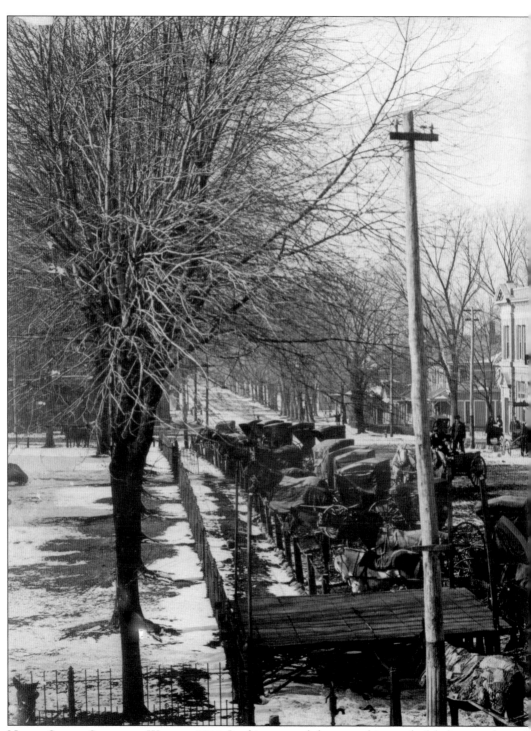

NORTH SIDE OF SQUARE IN WINTER, 1911. Looking toward the west, this wonderful photograph shows Ohio Street and the north side of the square on a very busy winter morning. The blanketed horses wait patiently at hitching posts while their owners conduct business across the street.

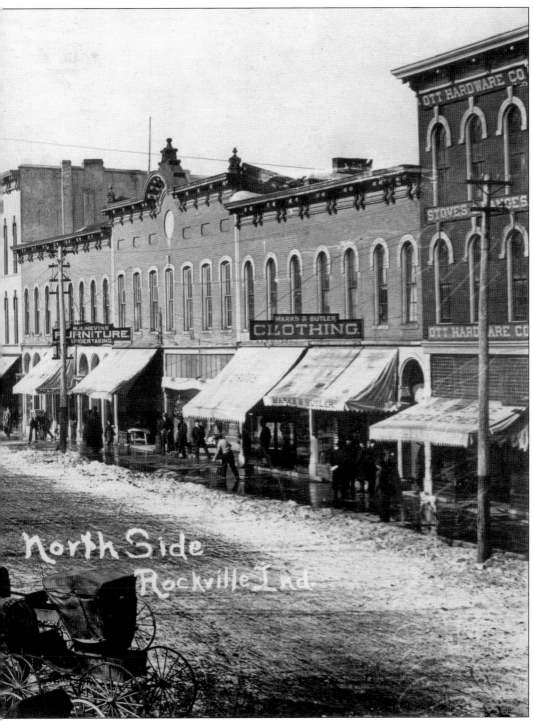

Being a rural community, many people only traveled to town once a week, especially during bad weather conditions. Automobiles were introduced to the community in 1908 but were rarely driven during poor road conditions in the winter months. (Lyle.)

THOMSON AND COMPANY WHOLESALE GROCER, 1892. Barrels of salt sit on Jefferson Street outside of the Thomson and Company Grocery. At the turn of the century, salt was very important because it was used as a food preservative. The basement housed a barber, while the second floor contained law offices. The upper floor was used for meetings of the Grand Army of the Republic, a fraternal organization composed of veterans of the Union Army. (PCHS.)

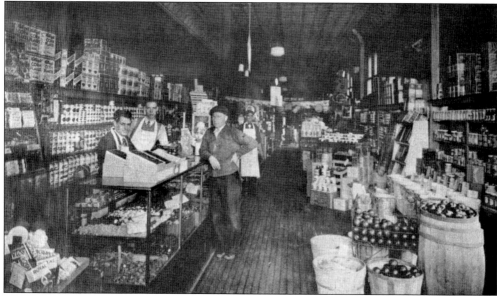

THOMSON AND COMPANY GROCERY INTERIOR, 1933. Located on the east corner of the north side, Thomson and Company was the oldest firm of its type in the city, opening in 1883. Harold and Vernard Thomas purchased the store in 1933 and changed the name to Thomas and Company. Pictured from left to right are Vernard Thomas, Lionel Clark, an unknown customer, and Harold Thomas. After participating in World War II, Clark established his own Regal Market on the west side and operated it until the mid-1980s. (PCHS.)

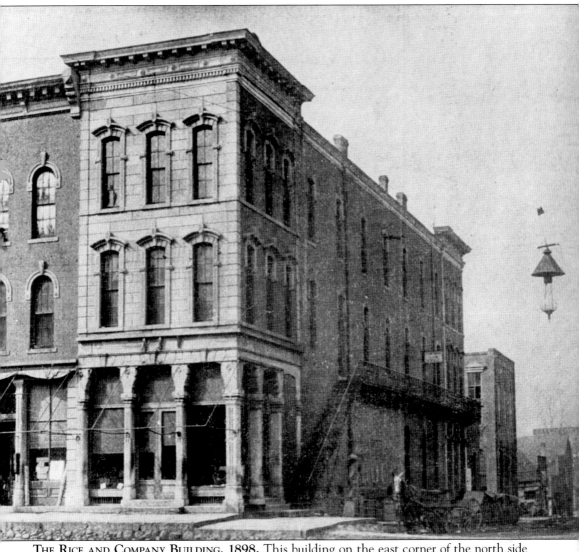

THE RICE AND COMPANY BUILDING, 1898. This building on the east corner of the north side was built in 1874 after a fire destroyed everything on the block except the old National Bank Building. The great fire began on this spot, which was occupied at the time by a jewelry store in a wood frame building. This photograph shows the magnificent facade of local limestone that made this building a jewel. Thomson and Company Retail Grocers occupied the first floor. As an 1896 advertisement attests, the grocers carried "a full and complete stock of Staple and Fancy Groceries, Fruits and Vegetables in season . . . and salt." The B. W. Shackelford Building is seen to the left. Shackelford was a dealer in dry goods, notions, and ready-made clothing. (PCHS.)

VIEW NORTHWEST FROM THE COURTHOUSE CLOCK TOWER, 1909. The F. R. Whipple home is seen on the corner of Ohio and Market Streets where the post office was built three decades later. Shoop's Livery Stable is located where the public library now stands and the Methodist church can be seen next to it. The National Bank Building, constructed in 1907, is on the lower right. In the center distance can be seen the roof of the graded school where the current Rockville Elementary School stands. (Lyle.)

VIEW NORTHEAST FROM THE COURTHOUSE CLOCK TOWER, 1909. Roofs of the businesses that line the north side of the square can be seen in the foreground. The roof in the right corner belongs to the Shackelford Building, and the long building to the right of it is the Rice and Company Building, which housed Thomson and Company Grocers. The newly built Rockville High School can be seen in the middle right of the photograph facing Jefferson Street. (Martin.)

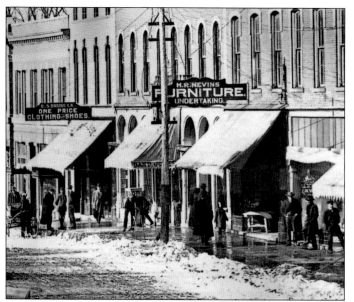

E. S. Brubeck One Price Clothing and Shoes, 1911. It appears as though E. S. Brubeck's store is doing brisk business on this winter morning. The shop was in the Harris Building next to the bank. It was also known as the IOOF or Odd Fellows Building. In 1890, Brubeck installed the first cash register in town. A clothing and shoe business remained in this location until 1985 when Smith's Shoes and Clothing Store closed. Smith's had been in that spot since 1915. (Martin.)

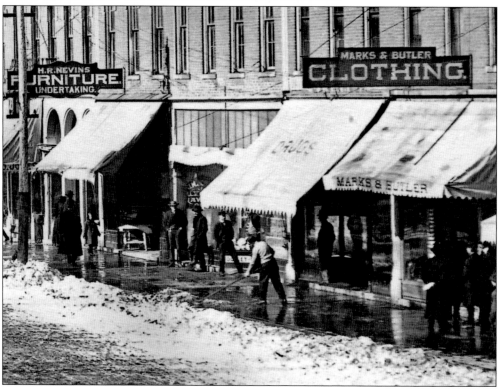

A Busy Weekday Morning on the North Side of Town, 1911. The sun has come out and the night's snowfall is being cleared in front of the Marks and Butler Clothing Company and H. R. Nevins Furniture and Undertaking. Since the mid-1800s, it was common for the furniture makers to also bury the dead. Making coffins was a natural extension of the cabinet making craft, and embalming was just part of the process. In many towns, the livery person, since he or she had the transportation, also became the undertaker. (Martin.)

HUNNICUTT JEWELER, BRUBECK SHOES, AND HORN RESTAURANT, c. 1892. The large pocket watch–shaped trade sign indicates the entrance to Hunnicutt Jewelry. The store occupied the east side of the old National Bank Building. Hunnicutt would occupy the same location in the new bank building. Horn's Restaurant was located on the north side in the 1890s before moving further east on Ohio Street to the Kelly Block. (PCHS.)

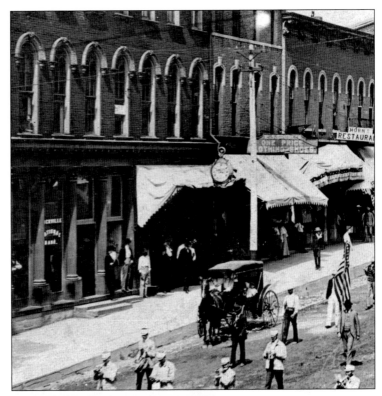

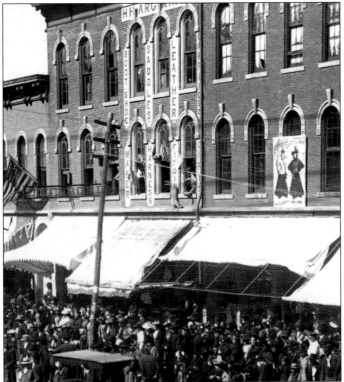

H. H. HARGRAVE, 1896. Located on the north side, H. H. Hargrave sold boots, saddles, harnesses, and leather goods. Ott Hardware is located next door to the left. It was established in 1861 as Ott and Price, then subsequently Ott and Boyd. An 1896 advertisement communicated that they "carry a full line of queensware, glassware, tinware, stoves, ranges, doors, sashes, Sherwin-Williams paints, farm machinery, sewer pipe, imported Portland and Louisville cements, lath, iron, and steel roofing." In this photograph, citizens have positioned themselves in the windows for a good view of a parade. (PCHS.)

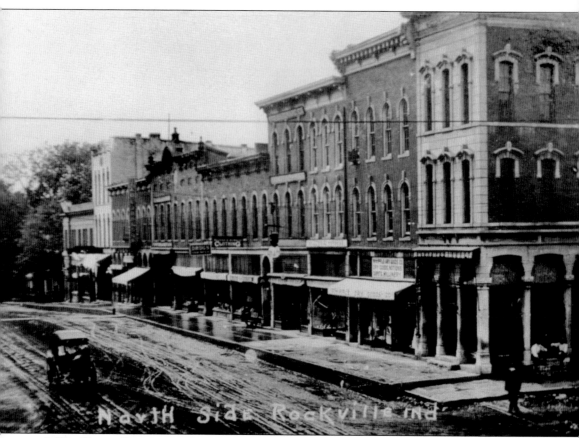

A WET DAY IN DOWNTOWN ROCKVILLE, 1914. This is one of the few photographs that captures the mud and gravel roads around the square in inclement weather. Shown from left to right after the "drugs" sign is Marks and Butler Clothing, Ott Hardware, G. F. Hibbit Buggies and Harness, Whipple's Dry Goods, and Thomson and Company Grocers. (PCHS.)

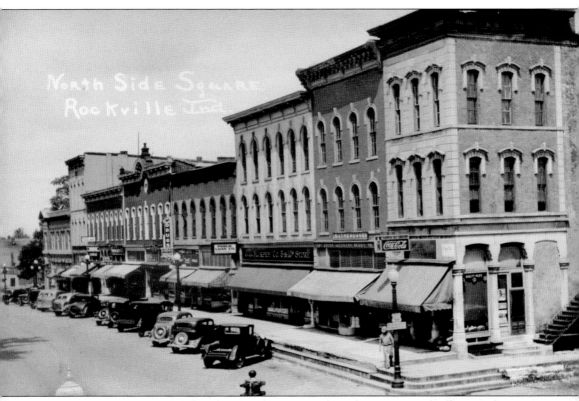

25 Years Later, c. 1939. This photograph captures a busy downtown Rockville around noon on a dry sunny day just prior to the onset of World War II. A penny scale stands on the sidewalk in front of G. C. Murphy's and the summer's watermelons are stacked in front of Thomas Grocery. Although the town was still suffering from the effects of the Great Depression, one would not know it by the apparent business in town. Within a few months, a number of the town's young men heeded the call to war. Many veterans returned from service and began their own businesses in town. (Lyle.)

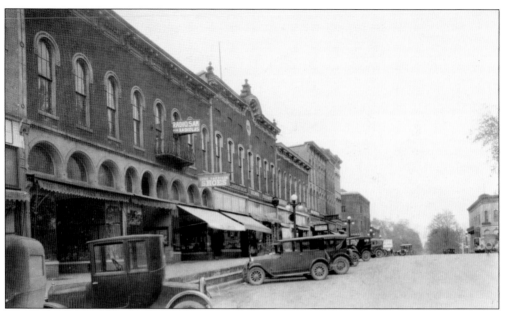

NORTH SIDE STORE FRONTS, 1926. The building with the arched clerestory windows (left) is known as the Innis Building and dates back to 1874. The building in the center with the curved cornice was built three years earlier. Innis Hall was a popular room for meetings and events and was on the second floor of the Innis Building, where the balcony can be seen. In this 1926 photograph, the block is home to Model Dry Goods and Lee Harrison Shoes, followed by an undertaker and Brown's Hardware. The Index Notion Store is farther down the block. (Martin.)

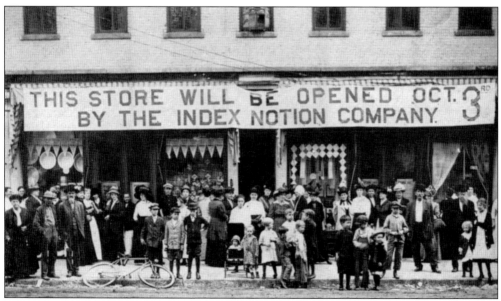

INDEX NOTION STORE GRAND OPENING, 1914. Located on the east side of the square about mid-block, the store was only in business at this site for a year. Then during a normal business day, the floor unexpectedly fell in, causing the ceiling to collapse as well. Customers, employees, and merchandise were suddenly plunged into the basement. Fortunately only minor injuries occurred. The store then moved to the north side. (PCHS.)

G. C. Murphy Store, c. 1930. Formerly the Index Notion Store, the business was purchased by the G. C. Murphy Company in 1927 and operated under that name for many years. It was open from 8 a.m. to 6 p.m. through the week and 9 a.m. to 10 p.m. on Saturday. An old-fashioned dime store, which has changed very little in the past 40 years, still occupies the location. (Lyle.)

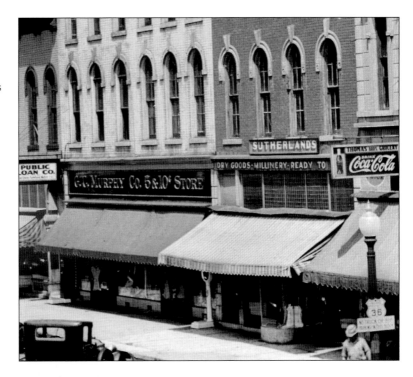

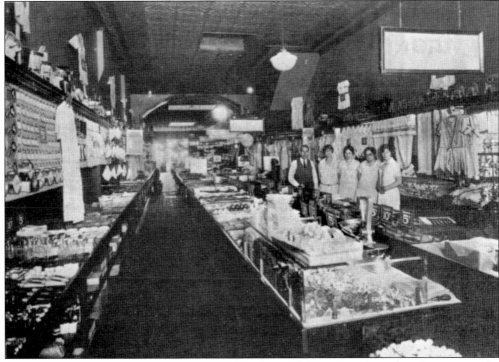

G. C. Murphy Store Interior, 1928. Truly a five and dime as evidenced in the signage, the well-stocked store carried most day-to-day things a person would need. One can notice dresses, baby bottles, alarm clocks, hosiery, curtains, and a wide assortment of bulk candy. (PCHS.)

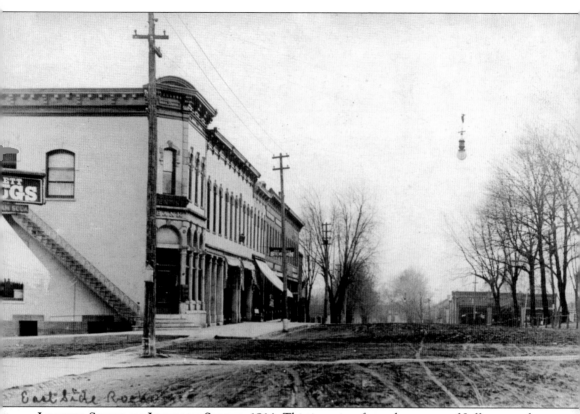

LOOKING SOUTH ON JEFFERSON STREET, 1914. This is a view from the corner of Jefferson and Ohio Streets, looking south. J. M. Ellett Drugs is on the left corner in the Opera House Building. This location was originally known as Myer's Corner and was home to the Rockville House, which burned in 1882. The Ellett drugstore offered "a complete line of drugs, chemicals, patent medicines, and a large stock of cigars and tobacco" according to an 1896 advertisement. This location was home to drugstores and soda fountains for more than a century. The Parke Bank Building is seen across the street. (Martin.)

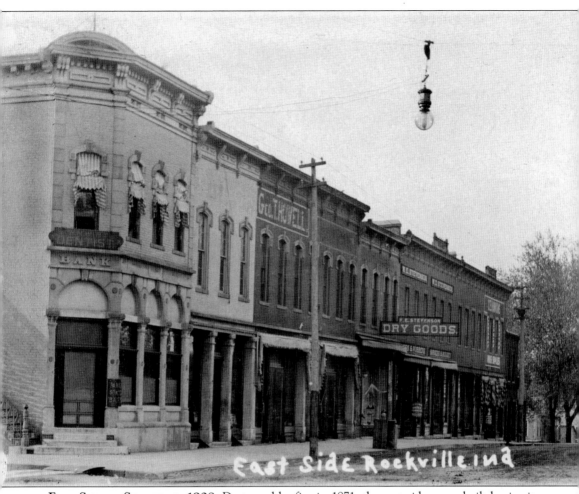

EAST SIDE OF SQUARE, C. 1908. Destroyed by fire in 1871, the east side was rebuilt beginning with the Parke Bank on the corner. F. E. Stevenson Dry Goods, a well-known supplier of shoes, harnesses, and buggies can be seen in the center of the block. C. E. Hawkins, another buggy, harness, and horse supplies dealer, is to the right. As buggy- and harness-making declined early in the century, many of these businesses became automobile makers or dealers. (Martin.)

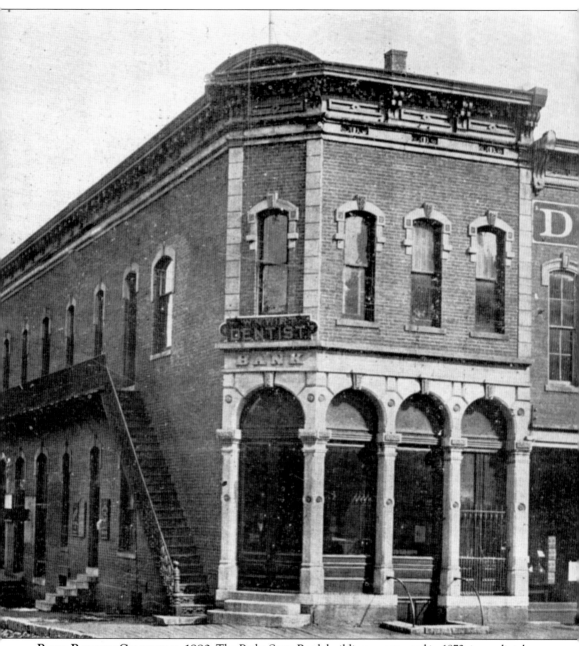

PARKE BANKING COMPANY, C. 1880. The Parke State Bank building was erected in 1872, immediately after the disastrous fire that destroyed the east side. It was built on the site of the old wood frame structure of Bates Drug Store. W. N. Wirt, Parke County's first dental surgeon, occupied offices on the second floor. Notice the wooden plank sidewalk in front of the building. (PCHS.)

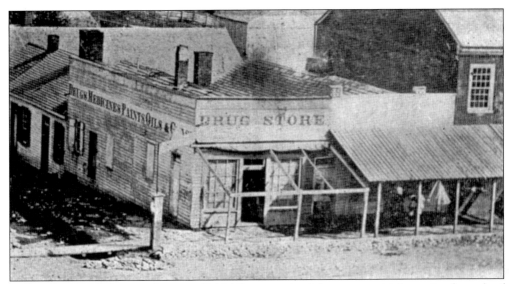

CORNER OF JEFFERSON AND OHIO, C. 1869. The east side of the square, which consisted mostly of wood frame buildings, went up in flames on the cold night of December 8, 1871. The Parke Banking Company Building replaced the drugstore on the corner less than a year later in 1872. (PCHS.)

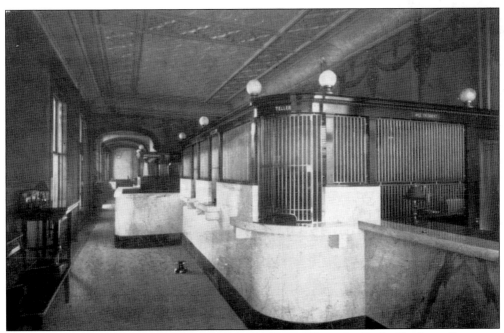

PARKE STATE BANK INTERIOR, 1911. Organized in 1873 as the Parke Banking Company with a capitalization of $20,000, it was reincorporated as the Parke State Bank in 1902 with capitalization of $75,000. This was at a time when many rural Americans earned less than $500 a year. (Martin.)

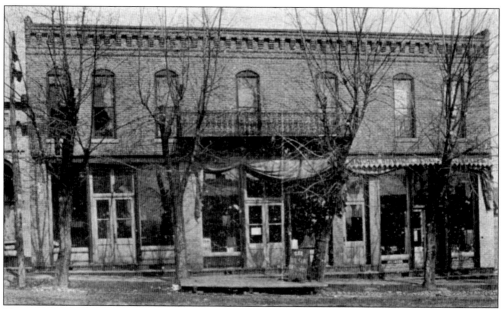

KELLY BLOCK, 1896. The Kelly Block was built in 1891 by M. Kelly and F. M. Hall. Hall's Jewelry Store was on the left and George Wilson's tailor shop was in the center. The *Parke County Journal* was on the right. The Hotel Grinley formerly occupied the site. (PCHS.)

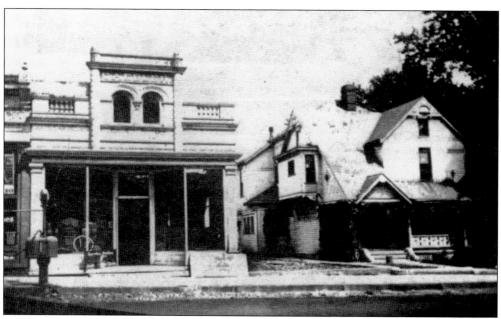

GAEBLER BUILDING, C. 1930. Located just east of the Kelly Block and Horn's Restaurant, the Gaebler Building was built sometime before 1904. It was originally home to the T. F. Gaebler Marble Shop, and was the county's only monument company at the time. Later it became home to a car dealership, laundromat, liquor store, and drugstore. It was moved to Billie Creek Village in 1982, and its unique tin siding, which was made to look like stone, was painstakingly restored. (PCHS.)

44

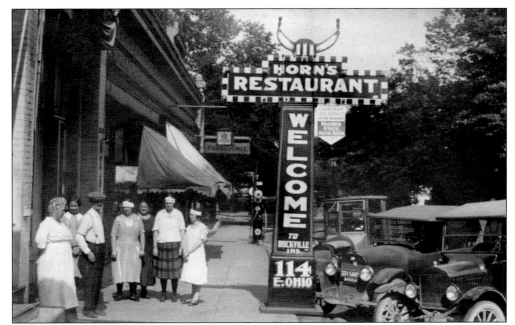

HORN'S RESTAURANT, C. 1929. Before moving to this location on Ohio Street around the turn of the century, Horn's Restaurant was located on the north side of the square. Large sidewalk monument signs such as this became the fashion around town during the Great Depression. A bank parking lot now occupies this site. (Lyle.)

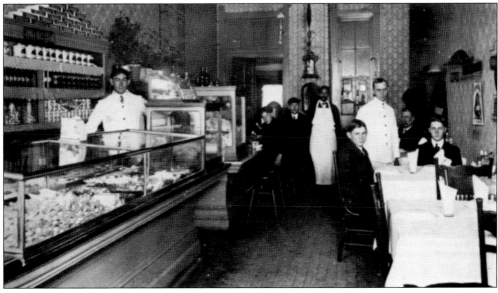

HORN'S RESTAURANT INTERIOR, C. 1915. With an assortment of candies, German silver display cases, linen tablecloths, and white-jacketed waiters, Horn's Restaurant was a very respectable place to eat. Notice a relatively new technology at the time, telephones, on the rear wall. (PCHS.)

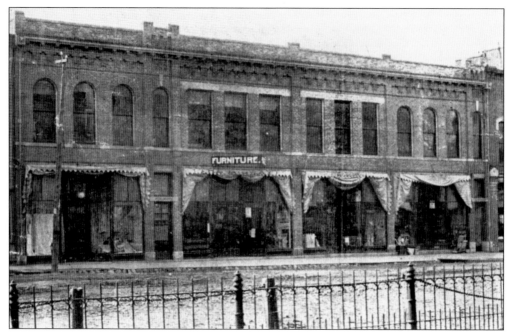

WEST SIDE OF THE SQUARE, 1896. Known as the Carlisle-Humpheries Block, this part of the west side was built in 1894 and replaced the frame building that housed Tona's Cigar Store. Pictured from left to right are Block's Emporium; McCoy, Hargrave, and McEwen's Furniture; O. P. Mahan's Drug Store; and the Carlisle Grocery. The upstairs was used as a meeting hall and for storage. This photograph also shows in detail the iron fence and hitching posts and chain that surrounded the courthouse. (PCHS.)

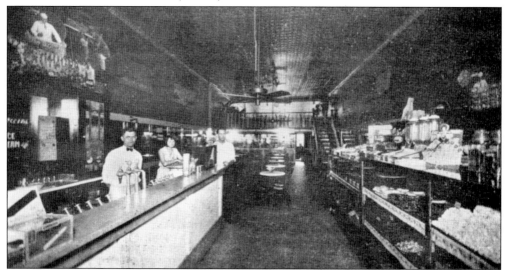

THE KANDY KITCHEN INTERIOR, 1928. The Kandy Kitchen was located next door to the Carlisle Grocery on the west side in the Carlisle-Humpheries Block. It was operated by James Nicholas and Bill James. As well as being a soda fountain, the Kandy Kitchen sold candy, ice cream, and roasted nuts. The roasting was done in the balcony area seen in the rear of the store. Bill James, Edna McCoy, and Chreas Minderman are shown from left to right at the soda fountain counter. (PCHS.)

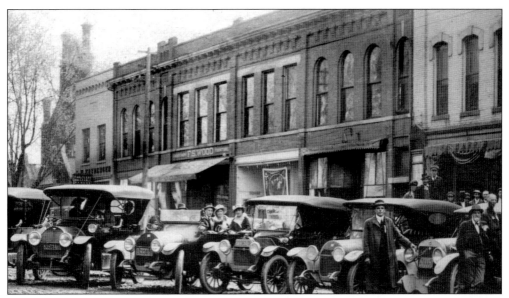

CARLISLE-HUMPHERIES BLOCK, 1915. Businesses shown here, from left to right, are Freyberger Hardware and Appliances, unknown, F. S. Wood Furniture, the Kandy Kitchen, and the Carlisle Grocery. This photograph was taken during the 1915 rally for the Pikes Peak Ocean to Ocean Highway. (PCHS.)

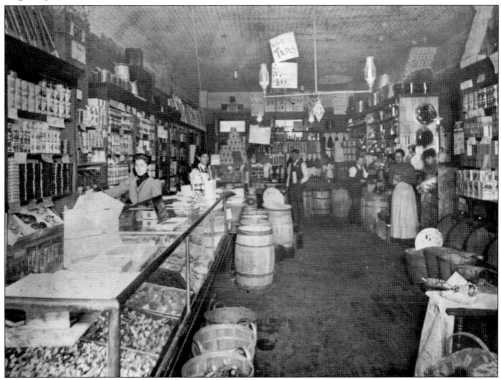

CARLISLE STORE INTERIOR, c. 1890. The Carlisle brothers operated a well-stocked grocery store that was connected with a restaurant that was advertised in 1896 as being the oldest in Rockville. Both were located in the Carlisle-Humpheries Block on the west side of the square. (PCHS.)

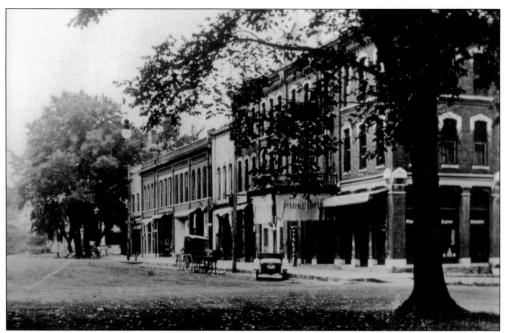

THE WEST SIDE OF THE SQUARE, C. 1912. Early in the century a card in the bathroom of the Parke Hotel was noted as stating, "All guests are entitled to a free bath after three consecutive nights lodging, provided you clean the bath tub; otherwise pay 35 cents and we will clean the tub. No bath to be taken or shaving done in this bathroom between 6:00 a.m. and 7:00 a.m." (PCHS.)

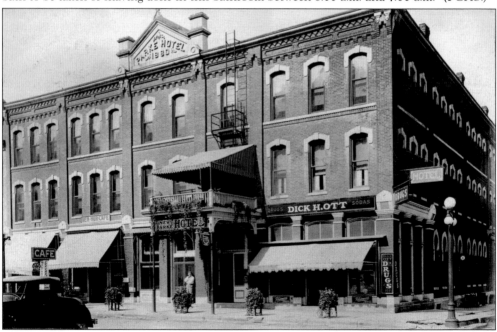

DICK OTT'S CORNER DRUG STORE, C. 1940. One of a series of drugstores in this location, this pharmacy and soda fountain was operated by Dick Ott around 1940. Paul Insley owned the last drugstore to occupy this location. He was in business for more than 40 years until his retirement in the 1990s. An Indiana State License Branch now occupies the site. (Indiana State Library.)

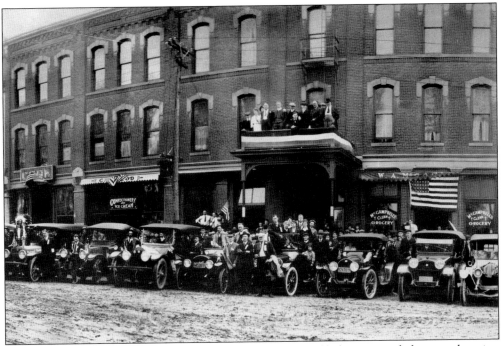

PARKE HOTEL BALCONY, 1915. Over the years the Parke Hotel balcony provided a prime location for viewing everything from parades to rallies and street carnivals. Many of Rockville's early photographs were taken using this balcony as the camera's vantage point. (PCHS.)

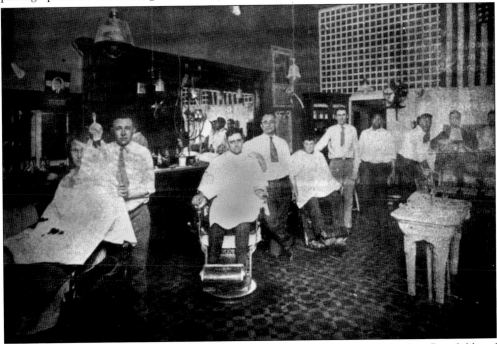

PARKE HOTEL BARBERSHOP, 1924. Ott Gibson ran his barbershop out of the first-floor lobby of the Parke Hotel. It appears to be a busy day, with three barbers on duty and a person shining shoes. Hot and cold baths were 25¢ and a shave was 10¢. (PCHS.)

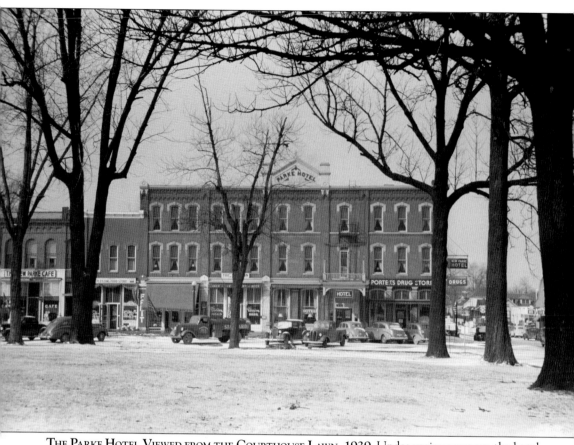

THE PARKE HOTEL VIEWED FROM THE COURTHOUSE LAWN, 1939. Under various owners, the hotel was in operation from 1880 until it closed its doors in 1984. In this photograph, the signage on the north of the building refers to the hotel as the New Parke Hotel and the 1880 date is painted white on the marquee sign atop the building. Notice that Porter's Drug Store occupied the corner location at this time. (Library of Congress.)

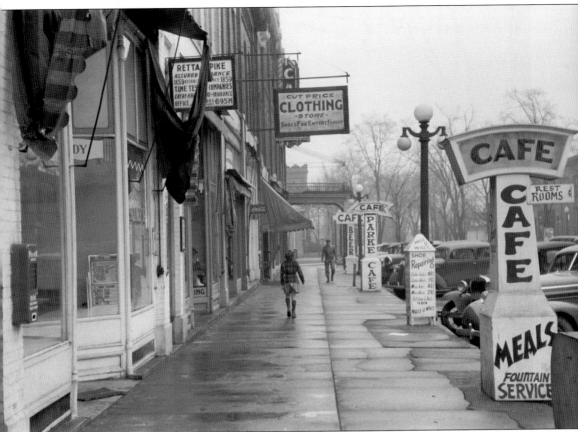

BUSINESSES ALONG THE WEST SIDE, 1939. This photograph captures the feel of a trip to the west side of the Rockville square on a cool and wet fall morning in 1939. It was shot by a photographer on assignment with the Farm Security Administration during the Great Depression. The photographers associated with the FSA were paid by the government to document the plight of farmers and rural America during the Depression years. (Library of Congress.)

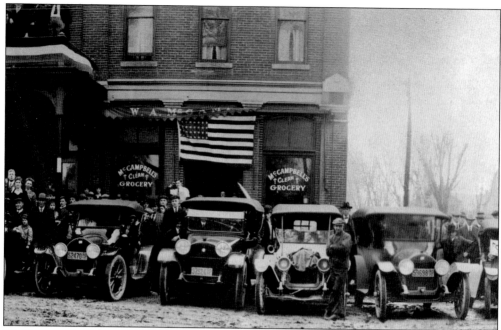

McCampbell's Clean Grocery, 1915. Before a number of drugstores occupied the Parke Hotel corner, Albert McCampbell's grocery store called the prime location home. It is seen here during a gathering promoting the Pikes Peak Ocean to Ocean Highway. (PCHS.)

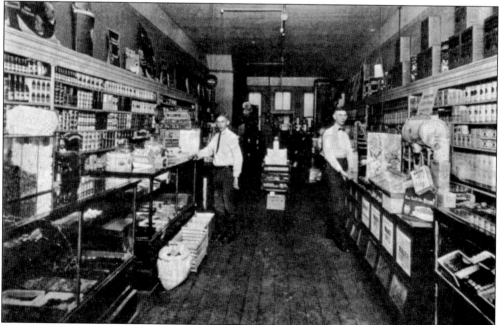

McCampbell's Clean Grocery Interior, 1916. This neat and tidy interior is very typical of what a turn of the century store looked like. Rows of display cases, counter jars, a bag rack, string holder, a Dayton scale, and neatly arranged canned goods are all on display. In a store such as this, the customer would ask the clerk for what he wanted, instead of serving himself as is done today. (PCHS.)

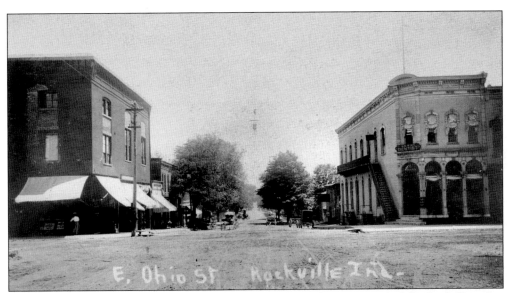

OHIO AND JEFFERSON STREETS LOOKING EAST, C. 1915. Looking east toward the Little Raccoon Valley, this is what the beginning of the Ocean to Ocean Highway looked like. It was still many years before improved pavement and marked roads became commonplace. The Opera House is seen on the left, soon after its conversion to a Masonic lodge, and the Kelly Block is seen past the Opera House to the left. (Martin.)

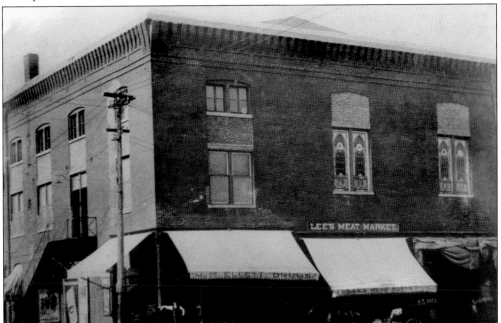

ROCKVILLE OPERA HOUSE, C. 1916. The Opera House was dedicated June 9, 1883. It was said to be one of the handsomest in the state. The auditorium on the second floor was two stories tall with a balcony, comfortably seating 800 people. The stage was 53 feet wide and 24 feet deep, and included a large drop curtain and 18 dressing rooms. The Opera House closed in 1907 and became a lodge for the Free and Accepted Masons. This photograph shows how the auditorium was then divided into two floors and the large windows were replaced. (PCHS.)

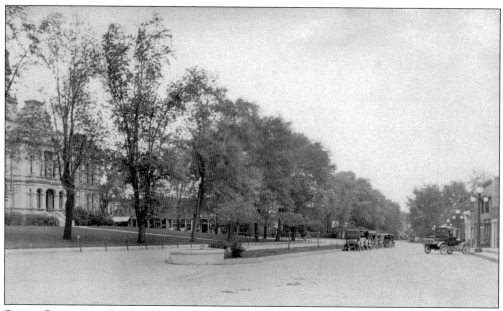

SOUTH SIDE OF THE SQUARE, 1930. In this 1930 photograph, the ornamental iron fence is gone and the concrete sidewalk around the courthouse has been completed. The final remnants of the hitching chain for horse and buggies still remains, having been removed completely from the other sides of the square. The road surface is still hard gravel, but soon became the paving brick that remains to this day. (Martin.)

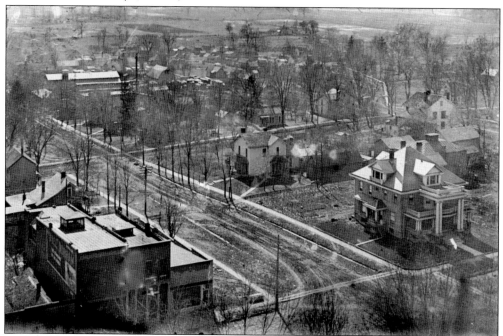

VIEW SOUTHWEST FROM THE COURTHOUSE CLOCK TOWER, 1909. Market Street can be seen heading south. In the left foreground one can see the offices of the *Rockville Republican*, and across the street to the right is the residence of C. M. Aydelotte. In the upper left corner can be seen the buildings of the Ferguson Lumber Company. (Martin.)

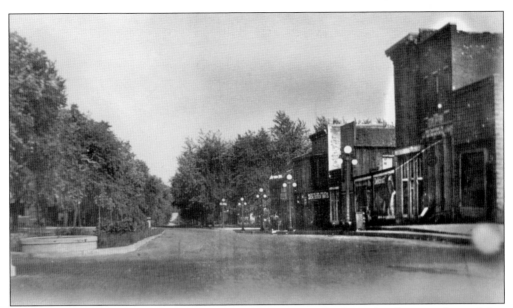

High Street Looking East, c. 1936. High Street was originally planned as the main thoroughfare through town. Because of this, the original town plan of 1823 made High Street 100 feet wide. The west side was thought to be next in importance and Market Street was platted at 80 feet wide. The east and north sides were considered least important, and were platted at less than 80 feet. (PCHS.)

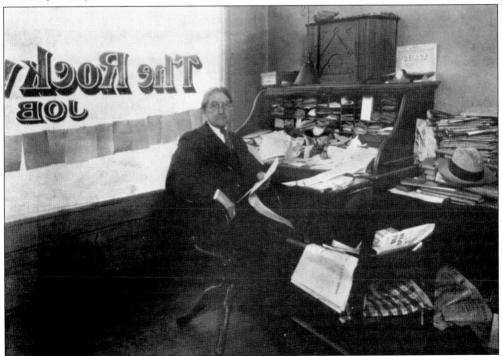

A. A. Hargrave, 1939. Shown at his roll-top desk in the front window of the *Rockville Republican*, A. A. Hargrave purchased the newspaper in 1888 and remained its publisher until he died in 1957. His son William Hargrave continued to publish the newspaper until 1971. (PCHS.)

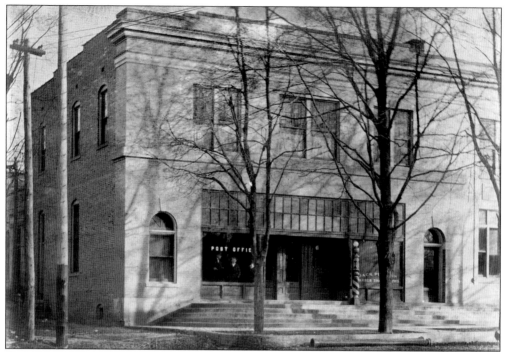

ROCKVILLE POST OFFICE, C. 1916. The town's first post office was in Patterson and McCall's store on the southwest corner of the square where the Presbyterian church now stands. In 1872, it moved to the south side of the square to the J. D. Hunt Building. In November 1907, the post office moved into this rental property on Market Street. The rental property was part of the newly constructed National Bank Building. (Martin.)

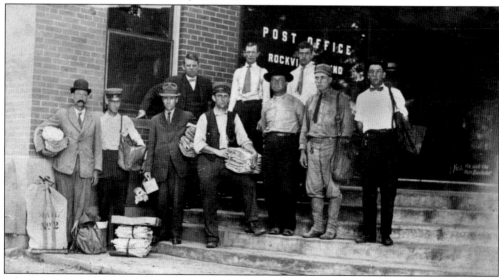

POSTAL DELIVERY WORKERS, C. 1916. Daily mail delivery began in Rockville in 1854 and was carried into town on hacks from Indianapolis. Around 1900, Dewey Cox became the town's first rural mail carrier, delivering from Rockville to the Bellmore area with a horse and buggy. In 1915, Rockville was designated as a town large enough to have a post office with village mail carriers, many of which can be seen in this photograph. (Martin.)

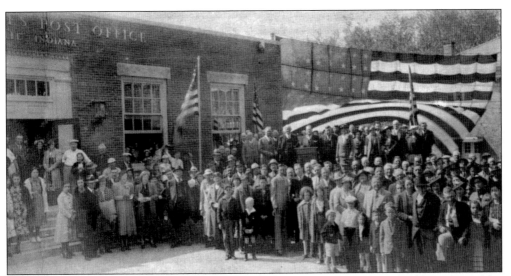

POST OFFICE DEDICATION CEREMONY, 1938. The Whipple home was located on the site of the current post office at the corner of Ohio and Market Streets. It was relocated to make room for the new post office building. The Rockville Post Office was dedicated on April 23, 1938, with a large ceremony and many attendees. It has changed very little over the years. (PCHS.)

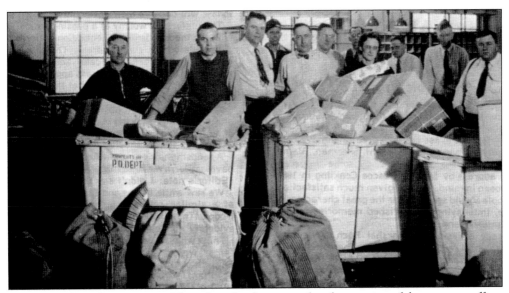

ROCKVILLE POST OFFICE, 1939. Thought to be shot soon after the opening of the new post office, this Christmas season photograph documents the volume of mail that the mail carriers delivered during holidays. (PCHS.)

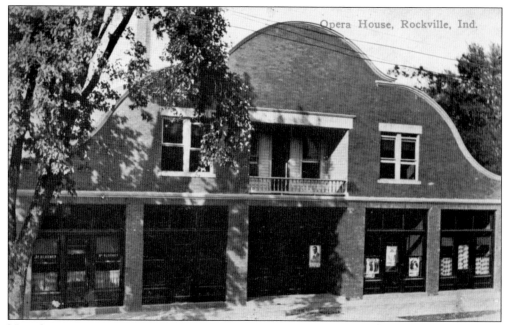

NEW OPERA HOUSE, 1915. The New Opera House was built in early 1912 at a cost of $20,000. The first production was *The Only Son* shown on October 15, 1912. Over the next few years it became a moving picture theatre, and its name was changed to the Ritz Theatre. It is currently one of the few active small town movie theatres still in existence. It is home to productions of the Parke Players, and still shows first run movies. (Martin.)

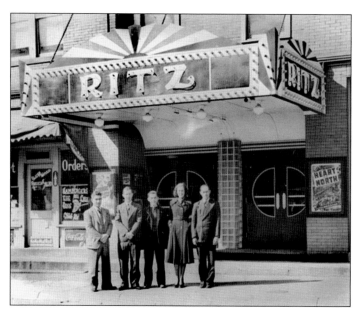

THE RITZ THEATRE, 1936. In 1929, talking pictures were shown in Rockville for the first time. Tuesday and Wednesday nights were for "talkies" and the other nights were for silent pictures. In the late 1930s, it cost 25¢ for adults and 10¢ for children to see a movie. Pictured from left to right are manager Bud Washburn, projectionist Dolph Davies, ticket vender Billy Lee, cashier Dorothy Davies, and building service person Woody Bradburn. (PCHS.)

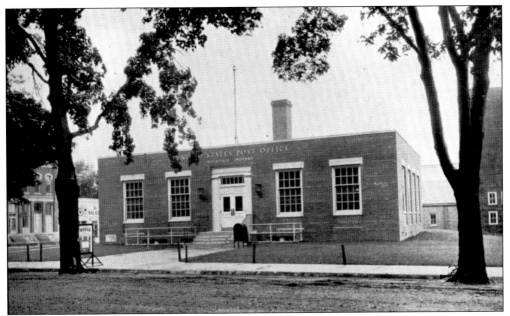

ROCKVILLE POST OFFICE, C. 1930. This is how the new post office looked just prior to World War II. Notice the still unpaved road in front of the building. The post office's appearance has changed very little over the following decades. (Martin.)

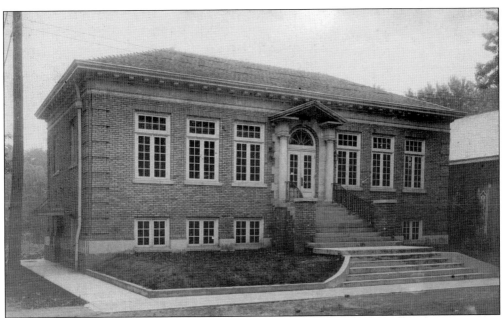

ROCKVILLE LIBRARY, C. 1940. With planning beginning in 1913, the community passed the required criteria and proceeded to raise the necessary matching funds to build a Carnegie library. Property that had been the location of the Boardman Livery Barn was purchased in 1914 and the building was soon completed. Dedicated in January 1916, the Rockville Public Library was one of 1,689 Carnegie libraries built throughout the country between 1883 and 1929. (Martin.)

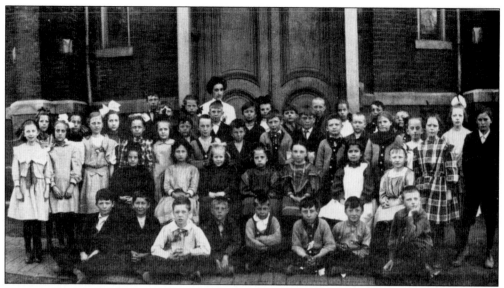

GRADED SCHOOL STUDENTS, 1910. Graded schools were first established in Parke County around 1860. These schools had a primary, intermediate, grammar, and high school. In 1876, the formal high school system of four years with a diploma went into effect, with the first graduating class consisting of only three students. Until 1872, a student's progress was monitored by verbal recitations of facts instead of the written test as it is today. (PCHS.)

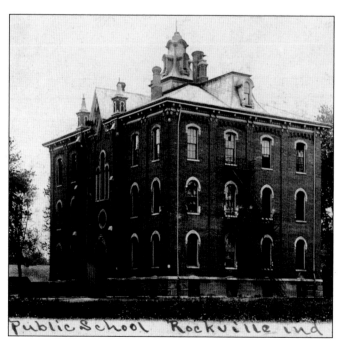

ROCKVILLE GRADED SCHOOL, c. 1909. The Rockville Public School Building, also known as the "Graded School," was completed in 1874. It was built on reclaimed swampland and contained a pond that many old timers recalled skating upon. The school was an 11-room building with three floors and a basement. The high school grades were on the third floor. The building remained in use for elementary education until January 1941 when the new elementary school was occupied. The new elementary school was built in a horseshoe shape around the old building. (Indiana State Library.)

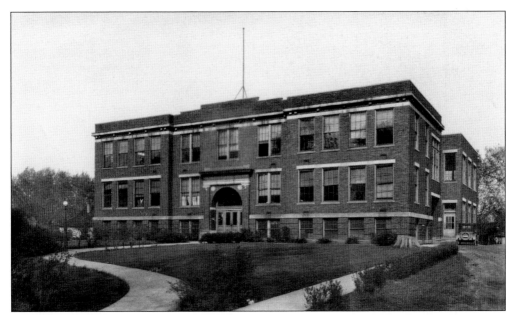

NEW HIGH SCHOOL BUILDING, C. 1930. Previously the high school had been taught on the third floor of the old Graded School. But due to the old building's deterioration the third floor was closed in 1908, leading to the need for a new high school. In 1909 the new Rockville High School on North Jefferson Street was dedicated with a ceremonial program, a banquet, and then a basketball game. (Martin.)

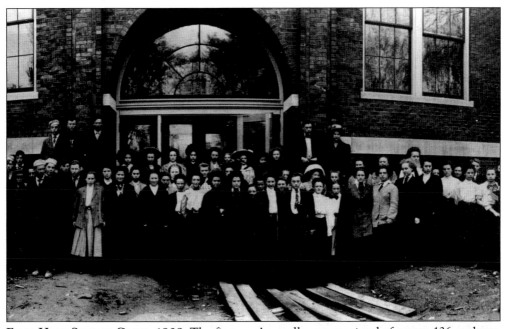

FIRST HIGH SCHOOL CLASS, 1909. The first year's enrollment consisted of a mere 136 students. Many more noteworthy individuals graduated over the next 50 years. By the 1950s the building had become overcrowded and a newer, more contemporary building was built in 1958 north of Howard Avenue. (Martin.)

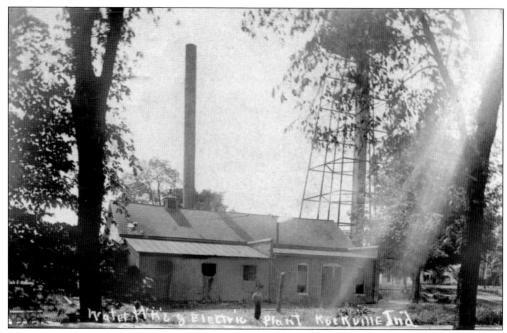

ROCKVILLE WATER WORKS AND ELECTRIC PLANT, 1909. Rockville's first general system of water supply was constructed in 1909. Until that time city residents used wells, and the public square was supplied with water from a deep well near the electric station. Since Rockville is situated on high ground, it was difficult to locate an adequate water supply. Deep wells east of town in the Little Raccoon Valley solved this problem. By 1916 most of the town had running water and adequate fire protection. (Martin.)

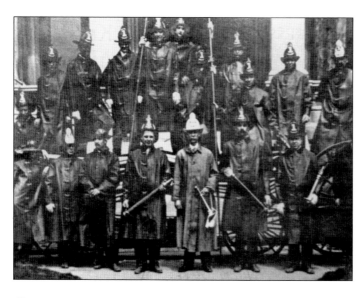

VOLUNTEER FIREMEN, c. 1909. After the National Bank Fire in 1906, Rockville organized its first volunteer fire department. The town was divided into wards so the volunteers would know where to respond to the fire. The steam whistle at the Rohm Brothers Mill was used to denote which ward the fireman should report to. Special combinations of long and short blasts indicated the area of town where the fire was. (PCHS.)

ROLLER MILL AND POND, LOOKING SOUTHWEST, 1896. The Rohm Brothers Roller Mill was built in 1893, east of town near the site of the failed 1855 Moore and Siler Grist Mill, and on the site of the 1865 Woolen Mill. The area was originally a ravine with a natural mineral spring flowing from the hillside. The spring was submerged when a pond was created for the gristmill; later, after the pond was drained, the spring vanished. Like so many other wood frame buildings of the era, the original Moore and Siler mill building was destroyed by fire in 1884. (PCHS.)

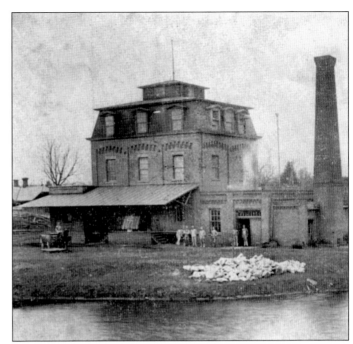

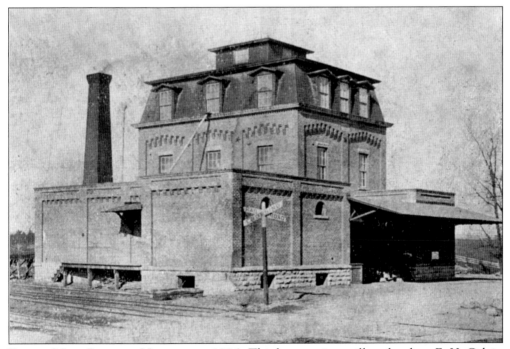

ROLLER MILL, LOOKING NORTHEAST, 1896. Third generation millers, brothers E. H. Calvin and George W. Rohm, built a fine, three-story brick roller mill on the east side of the railroad tracks near the old Vandalia depot. Due to the mill's prosperity and constant activity it was felt to be an appropriate first impression of the young town to railroad travelers. The mill marketed Double Six Big Domino Flour for regular baking and normal family use, and Patent brand flour for fancy baking. (PCHS.)

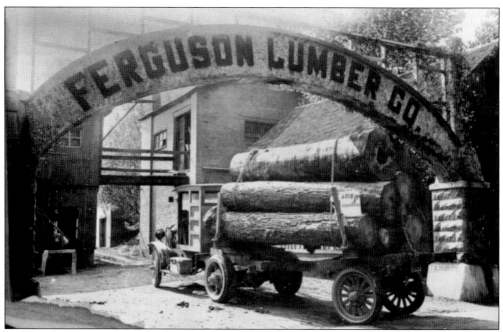

FERGUSON LUMBER COMPANY ENTRANCE, 1910. In 1868, Solon Ferguson started a sawmill on Sand Creek. Prior to that, Joseph Chance had started the first planing mill in the county, just south of the courthouse square. Solon Ferguson purchased the mill from Chance in 1870, and moved his family to Rockville. The company subsequently operated on this site for more than 130 years. (PCHS.)

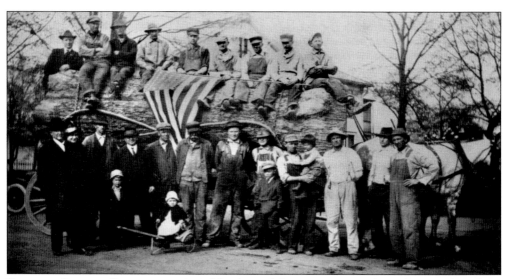

FERGUSON LUMBER COMPANY, C. 1920. Members of the company pose for a photograph with an enormous log cut from the forests of Parke County. The area around Rockville was particularly blessed with many square miles of virgin hardwood timber and a multitude of tree species. The close of the Civil War spelled doom for much of Parke County's native forests as the need for wood products increased and saw mills flourished. (PCHS.)

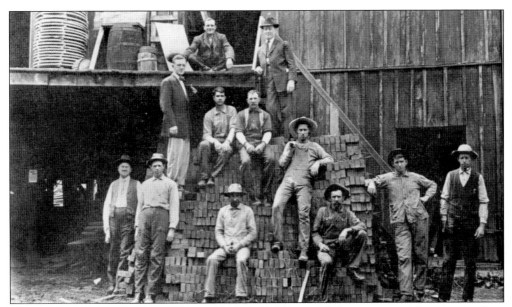

FERGUSON LUMBER COMPANY WORKERS, 1910. Employees of the company take time out from work for a photograph in front of the main building. Stories from the time indicate that there was a group of employees known as the "lost finger brigade" because of their apparent bad luck in cutting off fingers while manning the saw. (PCHS.)

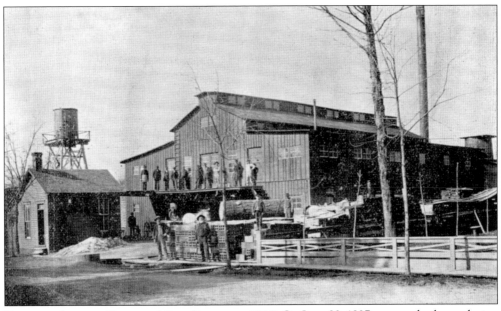

FERGUSON LUMBER COMPANY MAIN BUILDING, 1910. On June 23, 1897, a steam boiler explosion and resulting fire destroyed the mill and killed Solon Ferguson and Edward Stroughan. Solon's son, Walter, was badly injured. The mill was soon rebuilt and continued to operate as Ferguson and Company. As seen next to the fence, the company also offered cement and clay building products. (PCHS.)

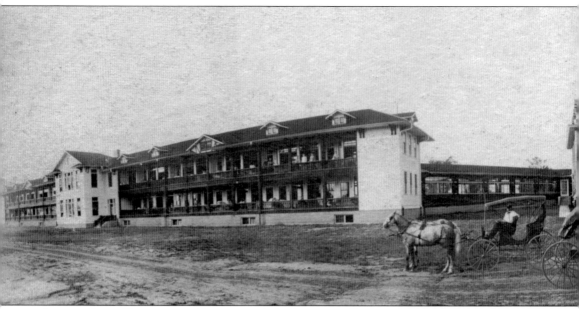

INDIANA STATE TUBERCULOSIS HOSPITAL, 1913. Constructed between 1907 and 1911, the hospital consisted of 504 acres east of Rockville. The hospital was built to handle a constant capacity of 160 patients, but it had a waiting list nearly double that number. The administration building was

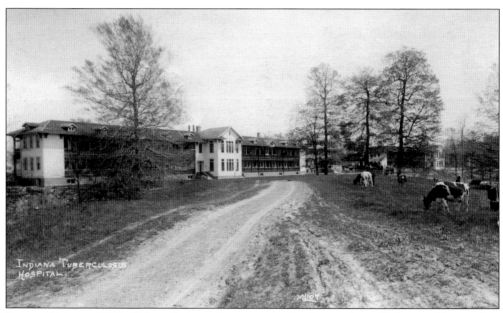

IDYLLIC SETTING, 1913. Tuberculosis, or "consumption" as it was also called, was widespread in the early part of the century, and sufferers were confined to sanitariums to keep the disease from spreading. It was felt that isolation, rest, therapy, and fresh air was beneficial. The idyllic setting outside Rockville fit that description. Even with treatment, there was no cure and many patients died. After the advent of the antibiotic streptomycin in the 1940s, sanitariums were either closed or converted to other uses. (Martin.)

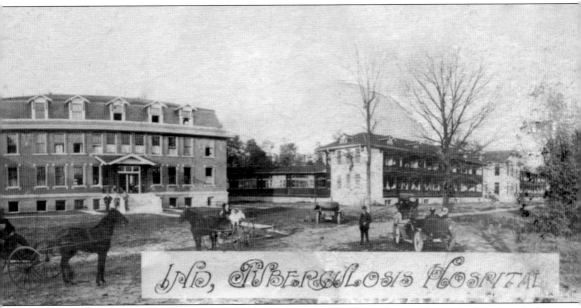

central to the facility and was flanked by men's and women's wards on either side. The hospital was also referred to as the "tuberculosis sanitarium." (Martin.)

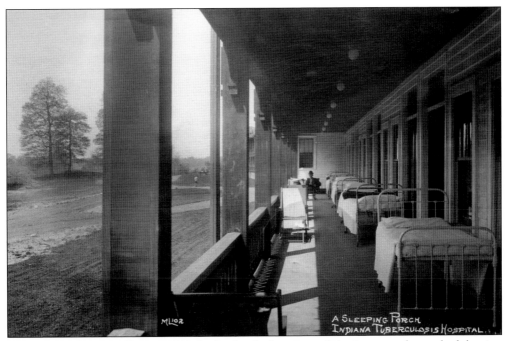

MEN'S WARD SLEEPING PORCH, 1913. In the days before air conditioning, many homes had sleeping porches, or screened areas that provided ventilation and relief from the oppressive Indiana summer heat. The Tuberculosis Sanitarium was no different. Fresh air was considered important to recovery, and patients were allowed to sleep on the porch when weather permitted. (Martin.)

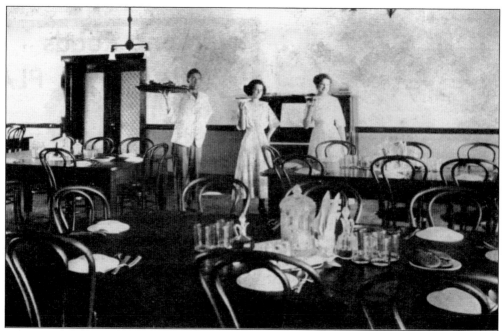

HOSPITAL DINING ROOM, 1913. Much of the food consumed at the hospital was grown on the sanitarium grounds. Poultry, corn, beef, pork, vegetables, and milk were produced either on or near the property. Breakfast was served at 7 a.m., dinner at noon, and supper at 5 p.m. The sanitarium was a city unto itself, and grew to become an important part of the community. (PCHS.)

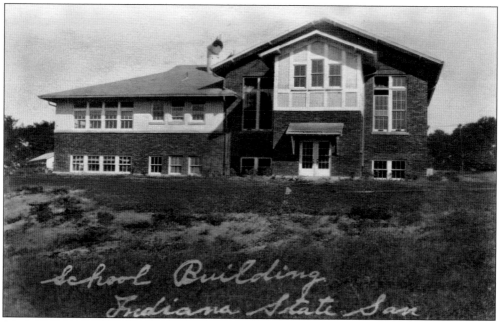

SCHOOL BUILDING, C. 1932. In 1922, an 80-bed children's hospital was opened south of the main hospital building. This new hospital required a school for the children, which was built in 1923. The grounds grew to include employee housing, a power plant, laundry, a dairy and horse barn, a slaughterhouse, and other facilities. (Martin.)

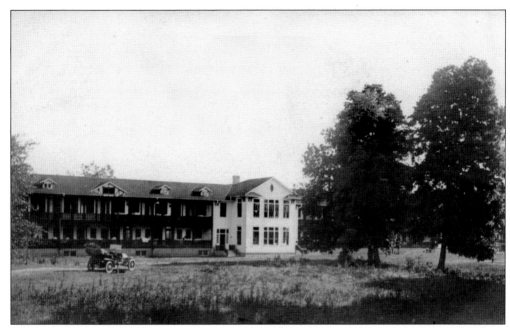

WOMEN'S WARD, 1913. The women's ward was located to the west of the administration building, and the men's ward was located to the east. The hospital capacity was 160 patients, but 165 to 175 soon became the average number receiving treatment. (Martin.)

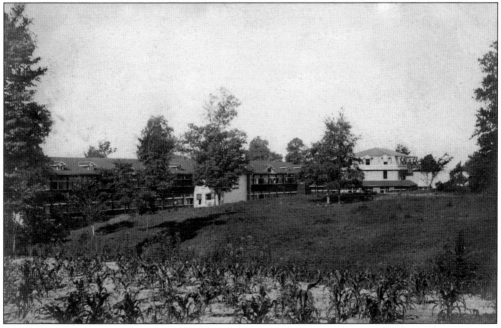

HOSPITAL GROUNDS, 1913. About half of the hospital's 504 acres were tillable, and many crops were grown for food. The rural setting on a hill provided rest and therapy for patients and many important jobs for local citizens. It quickly became the county's largest employer with a monthly payroll of more than $5,000. (Martin.)

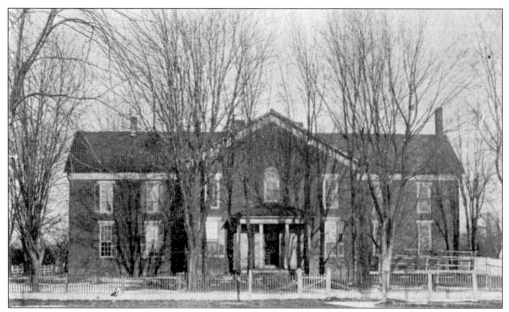

PARKE COUNTY POOR ASYLUM, 1896. Located about one and a half miles west of town, the asylum was built in 1867 by J. J. Daniels of covered bridge building fame. It was home for the county's destitute and insane, holding an average of 25 persons. A 200-acre farm provided food and was also part of the grounds. (PCHS.)

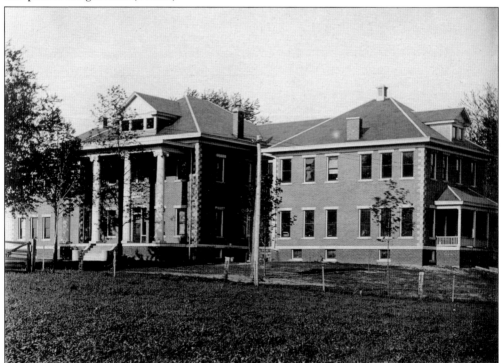

PARKE COUNTY ASYLUM, C. 1910. Built in 1906, this new building replaced the original asylum that was built in 1867. It was designed by L. W. Brown of Rockville, and built by James Boswell of Bloomingdale. The asylum was converted for use as a nursing home in 1958. (Martin.)

Three

A Town Rests

Rockville at Home, 1871–1945

In 1824, while many colonial cities were already a century old and living conditions were comparatively civilized, the early settlers in Indiana lived a very rudimentary life. Rockville was on the western edge of the new American frontier. The raw materials for early log dwellings had to be cut from the native forests that stretched unbroken from Kentucky northward. By the end of the Civil War, much of the land had been cleared and homes and farms began to resemble what we are accustomed to seeing today.

Market Street and Howard Avenue as well as High, Ohio, York, and College Streets saw the initial building of the fledgling town's larger homes. Thankfully many are still intact and are being preserved today in Rockville's Historical District. Although architecturally similar to today's homes, these homes of a century ago had many important differences that are difficult to comprehend today.

Until the first electric lights illuminated the town square in 1891, candles and oil lamps or lanterns provided light in the home. A wood-burning fireplace or coal stove provided heat. As a result, rooms were much darker and the heating was uneven throughout the home. By the late 1890s, many homes were being modernized to utilize the new warm air anthracite furnaces, and wiring was being run to accommodate the new electric light bulb.

The early years of the 20th century brought indoor plumbing to most homes. Prior to this, bathing was accomplished by bringing water into the house from an outside well, heating it on the stove, and then pouring it into a large tub. Because of this time-consuming process, people only bathed once a week, sometimes less. Also, the blessing of flushing toilets meant that one no longer had to face dark nights, strange insects, or inclement weather when visiting the outhouse.

Even the necessities of eating and sleeping in the summer were often made difficult by the presence of pests coming in through open windows. While cheesecloth and other open weave fabrics were used in the early 1800s, metal window screening material wasn't commercially available until after the Civil War and was not commonly utilized for many years after that.

In an 1896 publication, local writer and historian J. H. Beadle referred to these technological advances as "triumphing over the evils of nature."

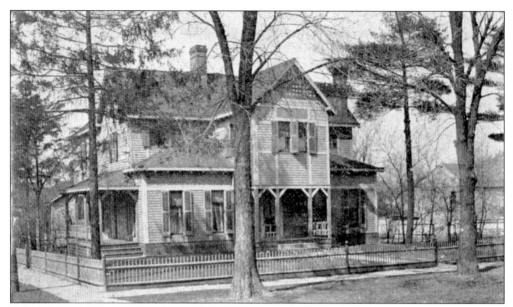

F. R. Whipple Home, 1896. Located on the corner of Ohio and Market Streets, this home was moved to east York Street in 1936 to make way for construction of the new post office. F. R. Whipple Sr. came to Rockville in 1861 and operated a dry goods store on the east side next to the Bates Drug Store until retiring in 1871. F. R. Whipple Jr. was a partner in the dry goods firm of Whipple and Overman. (PCHS.)

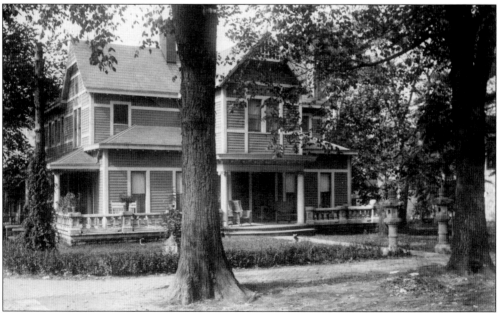

F. R. Whipple Home, 1912. Known as "Mayhacit," the Stick Style Victorian Whipple home was remodeled after the turn of the century. Large porches and a new entrance were built to reflect style influences popular at the time. Ship and train travel had changed the way people viewed their world, and Mrs. Whipple toured the globe like many other of her Victorian and Edwardian era contemporaries. The stone lanterns adorning the walkway were brought back from a trip to Japan. (Martin.)

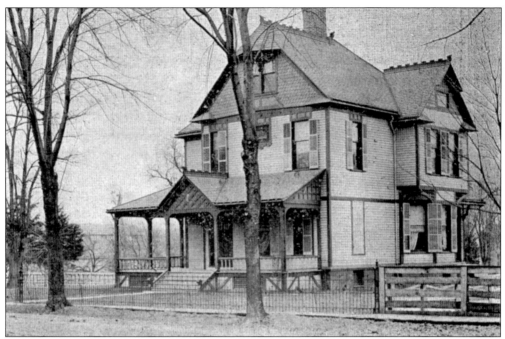

W. N. Wirt Home, 1896. W. N. Wirt was a dental surgeon who came to town in 1875 to become Rockville's first permanent dentist. For many years his office was on the second floor of the Parke Banking Company Building. This beautiful Victorian style home, located on High Street, was built by Isaac McFaddin. McFaddin came to Rockville in 1867 and is noted as being responsible for the finishing work inside the courthouse. (PCHS.)

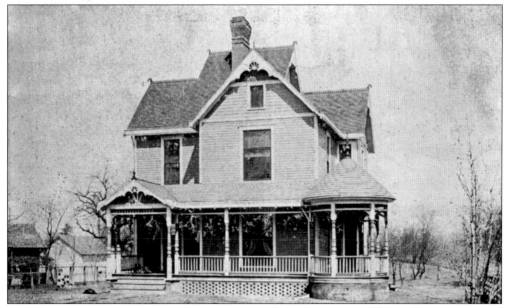

Frank Payne Home, 1896. Frank Payne operated the largest sawmill in Parke County, until timber became scarce. He then moved his operations south to Alabama and Mississippi. This home still stands on Howard Avenue, although its appearance has been substantially altered over the years. (PCHS.)

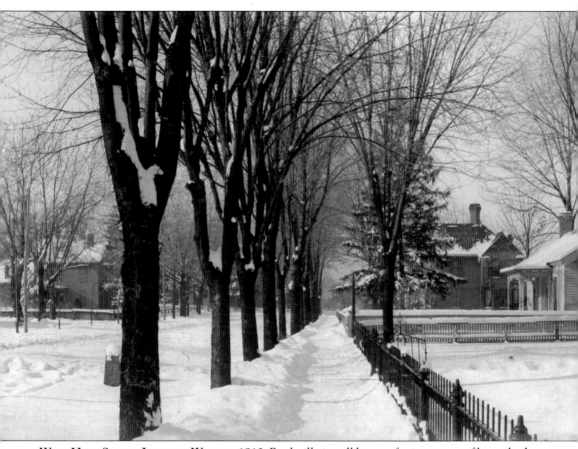

WEST HIGH STREET LOOKING WEST, C. 1910. Rockville is well known for its canopy of large shade trees. But that wasn't always the case. By the time of the Civil War, construction, fireplaces, and livestock had stripped most of the town bare of its native forest. Farsighted citizens replanted what they had lost, and within 50 years much of the town's greenery had returned. (PCHS.)

HOWARD AVENUE, C. 1909. Howard Avenue became a prominent thoroughfare in the city, and many of the town's most prominent early citizens built beautiful homes there. Because it was so heavily traveled, the wet weather of February and March would often make it nearly impassible. Wagons sank to their axles and horses to their knees. Because of this, it was among the first streets in Rockville to be graveled with rocks from Williams Creek, now known as Billie Creek. Howard Avenue was also the first residential street in town to have wooden sidewalks. This allowed female residents to walk to town without getting mud on their long skirts. (Martin.)

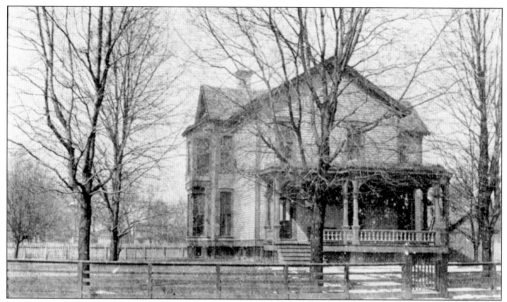

D. W. Stark Home, 1896. Born in Illinois in 1835, D. W. Stark was a partner in the general mercantile business of D. W. Stark and Company. Then after enlisting twice during the Civil War, he came home and engaged in the drug business as a member of Stark Brothers until he became a partner in the hardware firm McMillin, Stark, and Dooley in 1871. This fine home was located on Michigan Street and is no longer standing. (PCHS.)

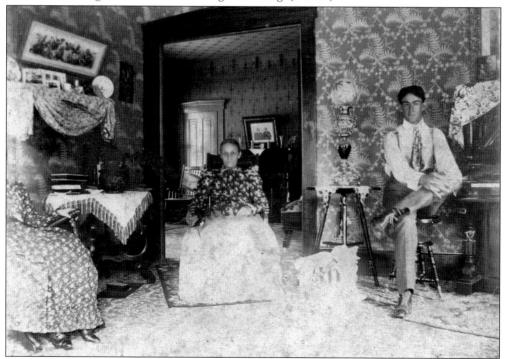

Typical Victorian Home Interior, c. 1900. The Victorian interior was often overflowing with pattern, color, knickknacks, and fabrics. Newly available machine-made objects allowed people to easily demonstrate their cultural interests as well as their newfound status and prosperity. (PCHS.)

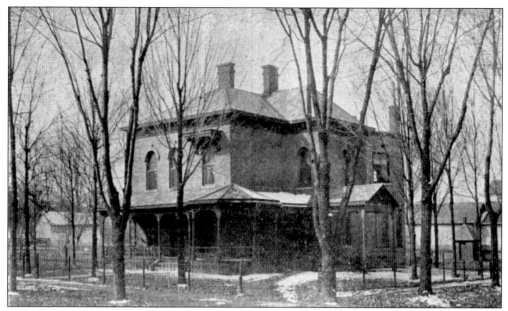

S. D. Puett Home, 1896. Samuel "Duncan" Puett was a prominent local Democrat, a member of the Rockville Bar Association, and partner in the law office of Maxwell and Puett. He also played the tuba in the Rockville Band. This Italianate style home was located at the southwest corner of College and Ohio Streets. (PCHS.)

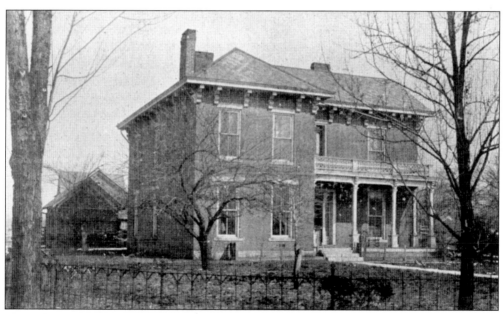

Henry Hargrave Home, 1896. An Englishman, Henry Hargrave came to Rockville in 1861 and began a shoe business on the north side of the square. The business grew to sell boots, saddles, harnesses, and leather goods, and he became one of the most prominent businesspersons in town. His wife, Hanna, ran a millinery business. The home is located on Howard Avenue. (PCHS.)

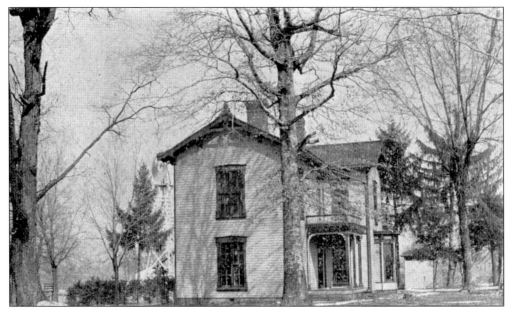

R. C. McWilliams Home, 1896. R. C. McWilliams came to Parke County from Kentucky in 1851 and started a livestock business in Washington Township, later moving to this home on Howard Avenue. Although still standing, the home's exterior has been altered. (PCHS.)

David Strouse Home, 1896. David Strouse was born in Rockville in 1847 and served hospital duty in the Civil War. He was deputy clerk of Parke County and served twice as the elected clerk for Rockville. His brother was Issac. R. Strouse, an early editor of the *Rockville Republican*. His brother Frank was the director of Beechwood Park. The home still stands on High Street but has been altered architecturally. (PCHS.)

POSING FOR THE CAMERA, C. 1890. The 1890s and early 1900s were considered by many to be the golden era of early photography, because of its new availability to the public and somewhat simplified production methods. Amateur photographers abounded, documenting early 19th century America and producing images of astounding beauty and historical significance. Here a group of friends pose in a field adjacent to the W. N. Wirt home. (PCHS.)

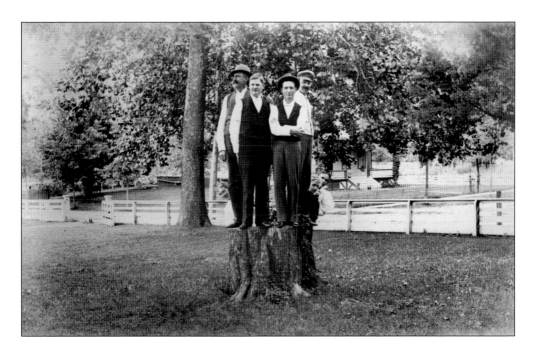

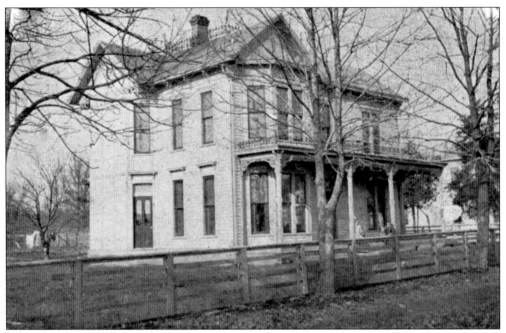

ISSAC STROUSE HOME, 1896. Issac Strouse became a partner in the *Rockville Republican* with John Beadle in 1882 and was later a commissioner on the site selection committee for the tuberculosis hospital. Juliet Strouse became known for her *Country Contributor* columns in the *Indianapolis News*, and her *The Ideas of a Plain Country Woman* column in the *Ladies' Home Journal*. (PCHS.)

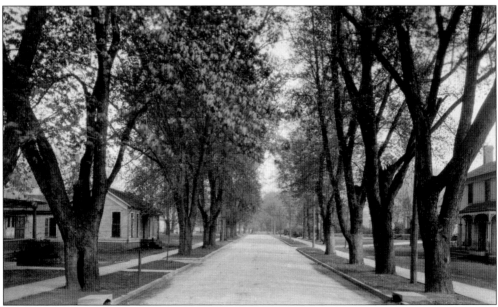

HOWARD AVENUE, C. 1926. This photograph looks southeast on Howard Avenue from Beadle Street. By 1926, curbs and drainage had been installed, the road was surfaced, and concrete sidewalks had been poured. This was a drastic change from a mere 40 years earlier when buggies often sank to their axles in the springtime mud. (Martin.)

Issac Strouse Home, 1910. The Issac Strouse home was altered after the turn of the century to reflect a more sophisticated neoclassical revival architectural style. Heirs of the Strouse family owned the home until the 1950s. The large home still stands on College Street. (Martin.)

York Street, 1907. A notation on the back of this photograph states that the large oak tree shown on the left was in front of 314 York Street. Judging by the girth of the trunk, it must have been present when the town was first settled in 1823. (Martin.)

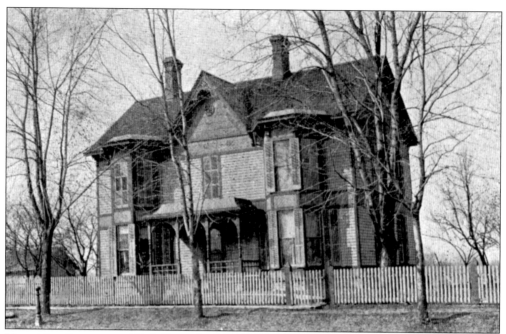

HENRY LEE RESIDENCE, 1896. Henry Lee, a native of Somersetshire, England, came to Rockville in 1872 and opened a butcher shop next to Ellet's Drug Store in the Opera House building. The business thrived for nearly 40 years. His home was located on Indiana Street. (PCHS.)

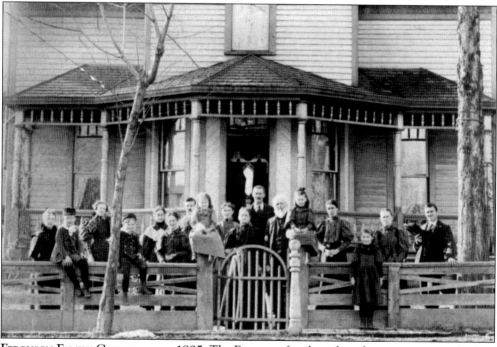

FERGUSON FAMILY GATHERING, C. 1895. The Ferguson family gathers for a portrait outside their home on Market Street. Notice the formality of dress that one associates with the Victorian Era, as well as the sturdy fence to keep out wandering livestock. This home still stands, although the appearance has changed over the past century. (PCHS.)

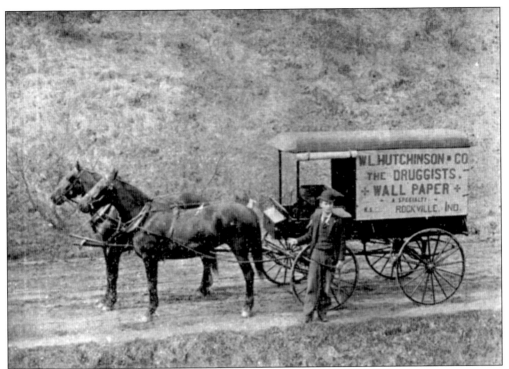

WALLPAPER AND DRUGS, 1896. J. B. Thompson, an experienced painter and paperhanger, is shown here manning the W. L. Hutchinson and Company wagon. As an advertisement of the period states, the wagon "traveled throughout the county to homes for those who wish to have their houses papered or painted and do not have time to come to town and select the necessary material." The wagon also carried a complete line of patent medicines and druggist's sundries. (PCHS.)

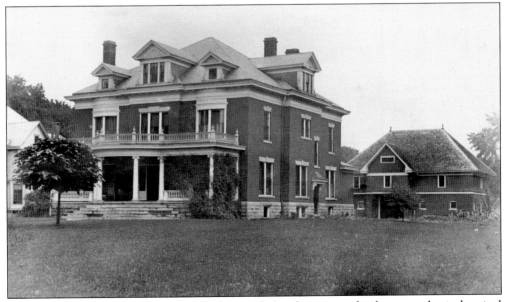

JOHN W. ADAMS RESIDENCE, 1914. The home of a local attorney, this large neoclassical revival home and carriage house still stands on Howard Avenue. (Martin.)

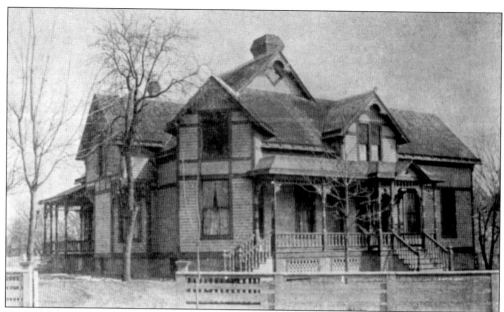

E. C. McMurtry Home, 1896. This fine Queen Anne–style home was located on Howard Avenue. McMurtry was a partner with H. B. Butler in the firm of McMurtry and Butler. An 1896 advertisement states that they sold dry goods, notions, fancy goods, clothing, boots and shoes, hats and caps, underwear, carpets, and cloaks. (PCHS.)

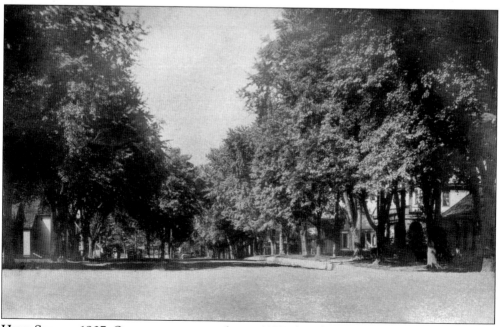

High Street, 1907. On a sunny summer day in 1907, this photograph looked west down the tree-lined thoroughfare of High Street. One can see parts of the E. S. Brubeck home on the right and the old Christian church building on the left. (Martin.)

ALFRED K. STARKE HOME, 1896. Born in Rockville in 1840, Starke entered into business as a clerk in the drugstore of Coffin and Davis at age 15. At the time of the Civil War, Starke and his brother D. W. Starke ran a drugstore on the north side of the square, until it was destroyed by fire in 1870. In 1873, he became one of the original proprietors of the Parke Banking Company, becoming its president. This gracious Italianate-style home is located on College Street. (PCHS.)

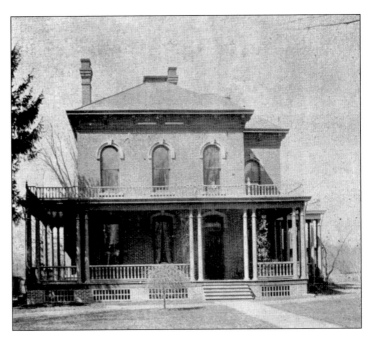

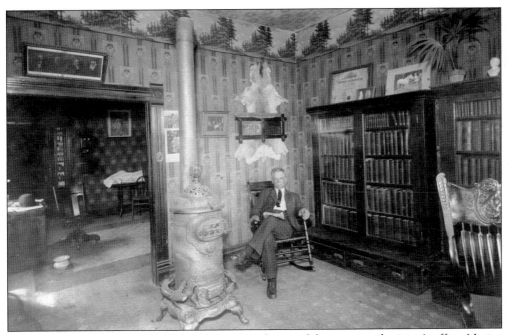

PHYSICIAN'S OFFICE, C. 1900. Pictured is a typical turn of the century physician's office. Notice the medicine bottles on a shelf in the rear examination room. A diploma is proudly displayed atop the glass door bookcases in the parlor. What appear to be numerous medical reference books can be seen on the shelves. (PCHS.)

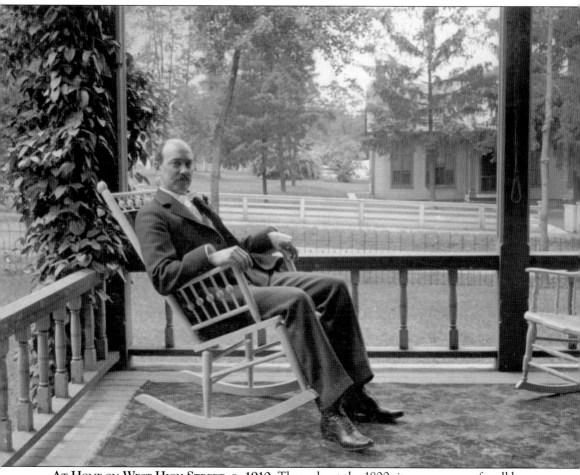

AT HOME ON WEST HIGH STREET, C. 1910. Throughout the 1800s it was common for all houses to have fences surrounding their property to keep out livestock, which was allowed to roam freely through town. It wasn't until the early 1890s that an ordinance was passed prohibiting livestock from running at large. Fences then became a personal preference rather than a necessity. (PCHS.)

Four

A Town on the Move
Rockville Travels, 1871–1945

Being an inland community 8 miles east of the nearest river of commerce, Rockville had to rely on other modes of transportation for travel and growth. Towns along the Wabash River could rely on keelboats and steamboats for passengers and freight, but Rockville had to rely on overland routes and the railroad.

In the early years, roads were simply dirt paths cut through the wilderness. They were dusty in the summer and all but impassible during the wet spring and winter months. Most small rivers and streams had to be forded. The first bridge in the area was at Armiesburg, built over the Big Raccoon River in 1853. The first improved road in the county was a plank road built in 1853 from the Wabash River to the Putnam County line. It was constructed of large wooden planks laid on a bed of gravel. The new road was smooth at first, in comparison to rutted dirt roads, but the planks eventually turned up at the ends, making the road nearly impassable.

Then around the time of the Civil War, it became important for Rockville to be more accessible. These improvements would have a great impact on the future of the town.

Beginning in 1865, the roads around the square and other areas of town were graveled with stone coming from Williams Creek. In 1867, a toll road made of gravel was built to Bellmore, and in 1868 a similar toll road was built to Annapolis. By 1872, all roads leading into Rockville had been graveled. Although this was a huge improvement, it would still be another half century before roads began to be surfaced with asphalt.

In 1860 the Evansville and Crawfordsville Railroad was completed from Evansville to Rockville. Rockville remained the northern terminus for the north to south railroad line until 1872, when the Logansport, Crawfordsville, and Southwestern Railroad line was built north to Logansport. The completion of the route did much more than make travel easier. The connection of the two routes had the practical impact of making Rockville part of the sprawling American railroad system and allowing travel to virtually anywhere. But perhaps just importantly, it provided the psychological awareness that the citizens of Rockville were no longer isolated and were finally connected to the outside world.

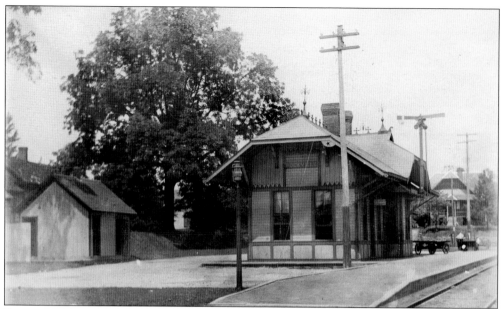

ROCKVILLE VANDALIA DEPOT, C. 1910. The original 1860 train depot was located south of the square near where south Jefferson and South Virginia Streets now intersect. The original Evansville and Crawfordsville Railroad line traveled down the center of Virginia Street, only a block from the courthouse, continuing through town to the north. The railroad was soon rerouted farther to the east and the depot shown here was built by the Vandalia Railroad in 1883 between Ohio and High Streets. (Martin.)

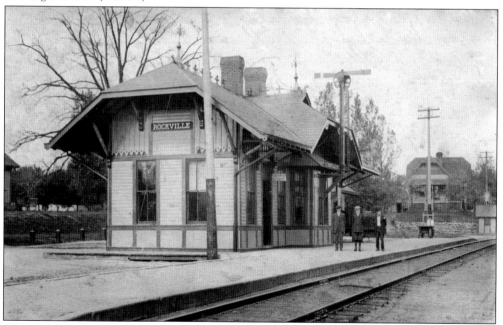

WAITING FOR THE TRAIN, C. 1915. These three young men appear to be waiting for the arrival of the next passenger train. Passenger service operated for 78 years, from 1860 to 1938, when the last passenger train pulled out of the Rockville depot. The Pennsylvania Railroad eventually abandoned the depot in 1971 when Parke County Inc. purchased it for use as a tourism center. (Martin.)

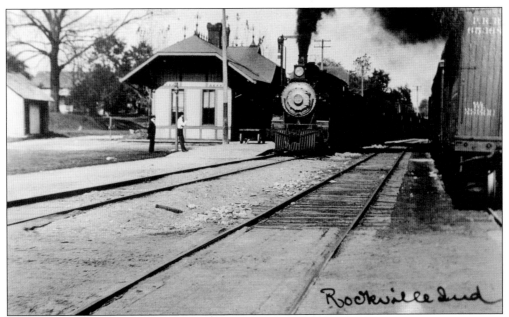

SOUTHBOUND LOCOMOTIVE, C. 1910. A coal-burning locomotive steams by the Rockville depot shortly after the turn of the century. From 1860 until 1871, all locomotives coming into town were wood burners, with large bonnet-shaped smokestacks. In 1871, the *John Lee* came into Rockville on newly built tracks from the north. Its small smokestack emitting coal-black smoke was a strange site to viewers present that December morning. (PCHS.)

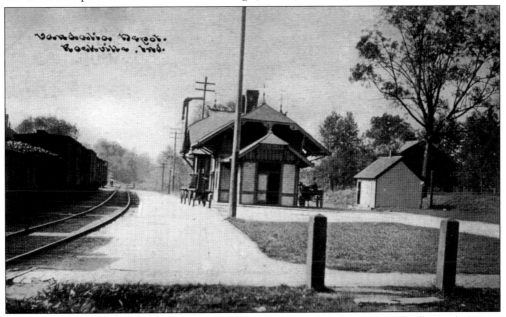

VANDALIA DEPOT LOOKING SOUTH, 1912. Telegraph lines didn't arrive in Rockville until 1870, so all news relating to the Civil War came in on the evening train. A long blast on the train whistle signaled good news and a short blast signaled bad news. On the evening of April 14, a short blast signaled President Lincoln's death. Those gathered at the station saw Bony Lyon's locomotive draped in black for mourning. (Martin.)

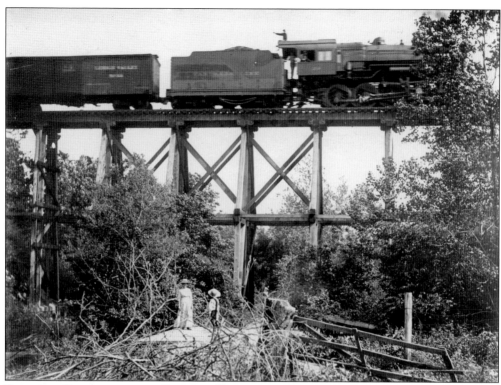

RAILROAD TRESTLE AND THE PUMPKIN VINE, C. 1900. Reportedly the track from Rockville to Logansport was so rough, crooked, and dangerous it became known far and wide as "the Pumpkin Vine." Undoubtedly an exaggeration, it was said that the death rate of its trainmen were as high as that of the average company of soldiers in the Civil War. Since the 90-foot grade coming into Rockville limited further railroad growth, its hoped-for east to west lines never materialized. (Martin.)

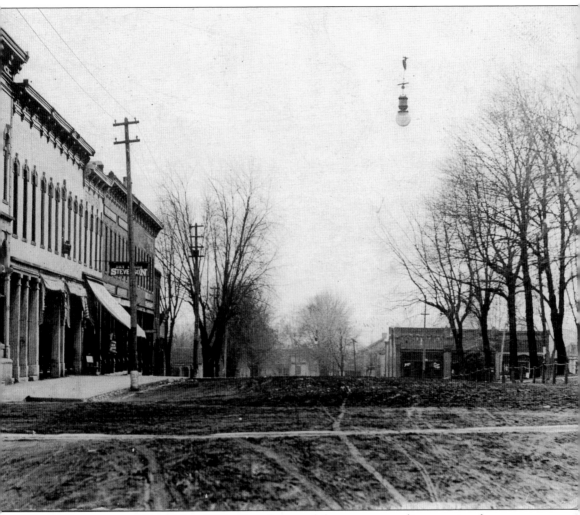

ROAD CONDITIONS, 1914. Before 1865, all roads around the square were dirt, meaning they were muddy in the winter and dusty in the summer. In 1865, Thomas Rice proposed that the roads be graveled with stone from William's Creek. After debate, due to the fear of damaging the creek, it was decided to gravel the north side. In 1865, the north side was graded, leveled, and graveled, and the results were very pleasing. By 1875, the entire square had been graded and graveled. This photograph shows the road conditions on the east side of the square. (Martin.)

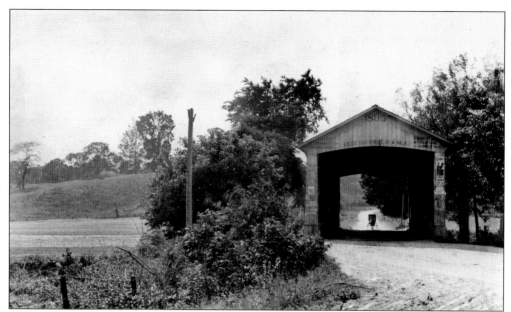

WILLIAM'S CREEK, 1914. William's Creek was named after Caleb Williams, who came to Adams Township in 1821 and started a tannery and a store. This gravel road later became the first roadbed for the Pikes Peak Ocean to Ocean Highway, as it made its way east out of town. When it became U.S. Route 36, the highway was diverted to the north. Today this covered bridge is the centerpiece of Billie Creek Village. (Martin.)

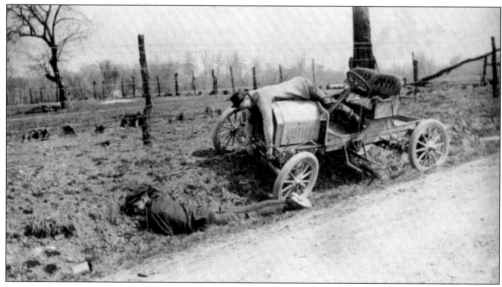

YOUNG PRANKSTERS, C. 1915. County roads were dry and dusty in the summer and wet and muddy in the winter, with many deep ruts and potholes. The higher speeds and undependable tires of newfangled automobiles led to many accidents. Many people complained that the new fad did nothing except scare the horses. Fortunately these young folks are just showing off for the camera. (PCHS.)

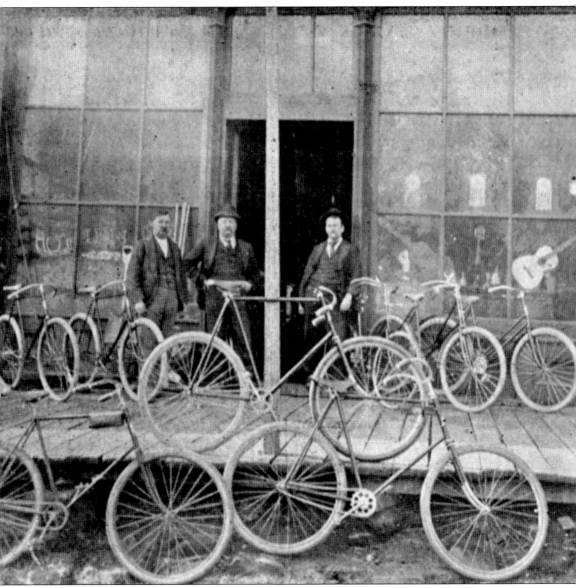

BULION AND SWAIM, 1896. This interesting store carried a full line of groceries and general merchandise. It also carried guns and ammunition and a good selection of bicycles and musical instruments. The first two-wheel buggy, as it was called, was introduced to Rockville citizens in the spring of 1868. Reports noted that a group of 20 pooled their money and purchased one. Apparently good times and a few spills were had by all as they rode the contraption around and around the wooden floor of National Hall on the upper floor of the old National Bank Building. (PCHS.)

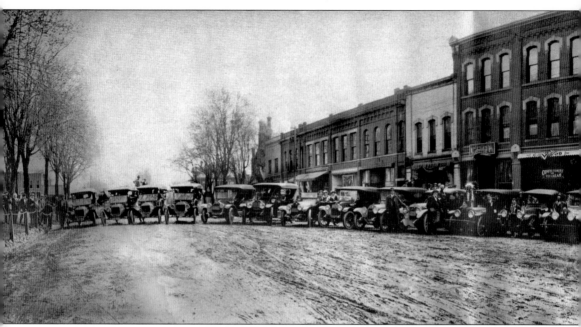

OCEAN TO OCEAN HIGHWAY BOOSTERS, 1915. Spanning the continent from New York City to Los Angeles, the Pikes Peak Ocean to Ocean Highway provided a means of travel when paved roads were rare and travel by automobiles was an adventure. Local road boosters such as those shown in this photograph offered money and road improvements to assure that their towns were on the

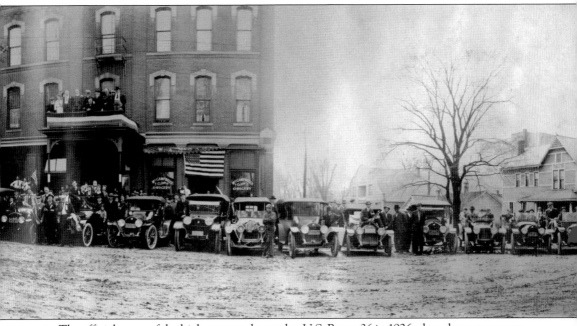

route. The official name of the highway was changed to U.S. Route 36 in 1926 when the government adopted a uniform numbering system. By this time, the need for private boosters and trail associations were not necessary since federal and state governments had begun their own highway funding programs. (PCHS.)

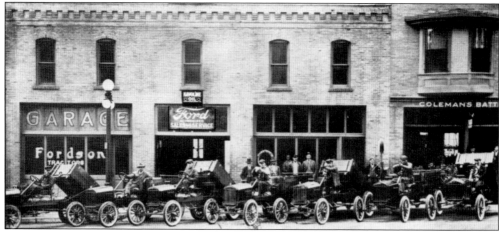

The Ford Agency, 1922. In 1918, Guy Alden and his brother Sid purchased the Ford Agency and located to the south side of the square into a garage previously owned by E. J. Coleman. In this 1922 photograph, Fordson trucks are being delivered to the Parke County Highway Department. Despite not being able to sell cars from 1941 to 1946 due to the war, the Ford Agency remained in business by servicing older automobiles. Alden remained in this location until moving to U.S. Route 41 in 1967. (PCHS.)

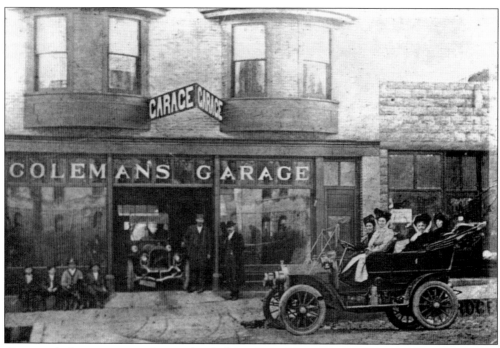

Coleman's Garage, 1909. Pictured is Coleman's Garage on the south side of the square as it appeared in 1909. Coleman was an established machinist and plumber before moving into the automobile business. It was the only garage in the area to have an automobile washing room located at the rear of the garage. E. J. Coleman is standing in the doorway Mrs. Coleman is driving the automobile, accompanied by her mother, aunt, and sister. (PCHS.)

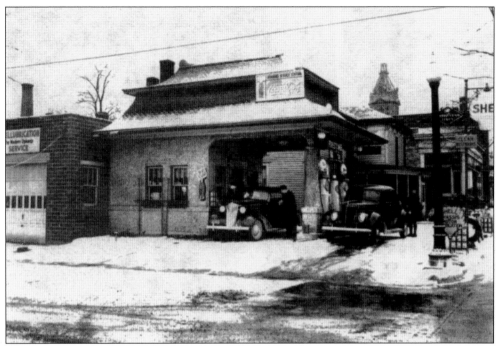

BORDON'S SERVICE STATION, C. 1936. Located at the corner of Virginia and Ohio Streets, this pagoda-style station served travelers as a Shell Service Station through the 1930s. It switched brands many times over the years and remained open as a working station into the early 1970s. It was torn down in 2005 and replaced by the current American Legion building. (PCHS.)

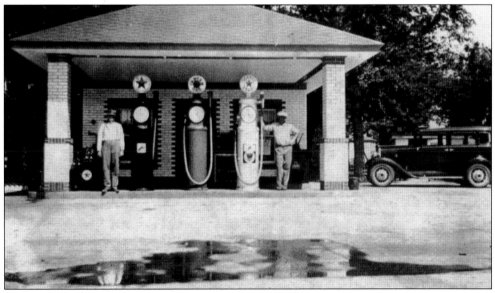

TEXACO STATION, C. 1932. Aaron Lewis and Charlie Welch stand beside large dial gas pumps at the gas station on the northwest corner of the intersection of Indiana Route 36 and U.S. Route 41. This station later became an Imperial station in the 1970s before eventually being demolished to make way for a CVS store. (PCHS.)

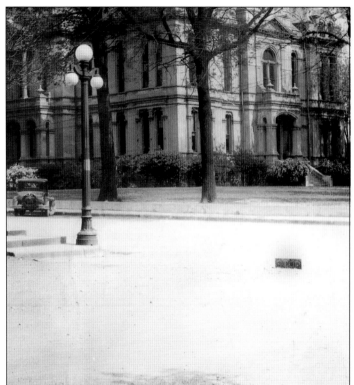

UNIQUE STOP SIGN, C. 1935. Even though stop signs were standardized as black text on a white background and octagonal in shape by 1922, this small stop sign at ground level in the center of the intersection of Market and Ohio Streets is a curious departure from that rule. (Evans.)

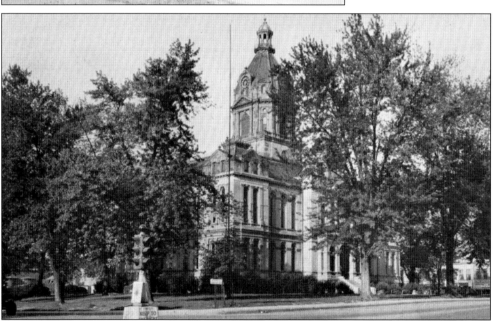

FIRST TRAFFIC SIGNAL, C. 1940. The town's first traffic signal was installed in 1928. It is visible at the bottom left center of this photograph. The signal's awkward location, on a cement base in the center of the street, caused a long series of head-on collisions, sideswipes, and near misses. The sign was especially dangerous on foggy or rainy days and after dark when it was difficult to see. (Martin.)

Five

A TOWN RELAXES

ROCKVILLE AT LEISURE, 1871–1945

A century before the simple flick of a switch could bring entertainment directly into the home, opportunities for diversion were a special event. These occasions were valued as a time for social intercourse and learning, and they formed the primary means by which community unity and values were advanced.

From parades for nearly any occasion to grand dances in the old National Hall, from street fairs around the courthouse square to circus performances at the old fairgrounds, the early citizens of Rockville grasped every opportunity available to amuse themselves.

National Hall, on the upper floor of the old National Bank Building, and the old and new opera houses, were the sites of many lectures, festivals, celebrations, and professional theatrical performances. The old fairgrounds west of town were home to many horse races, traveling circuses, and other gatherings. By far the largest celebration was in September 1875 at Ott's Woods, northeast of town. The event saw a turnout of nearly 30,000 for a reunion of Indiana and Illinois Civil War soldiers. Union veterans pitched more than 500 tents in the woods and for two days General Sherman was the guest. On the second day, dressed in his full dress uniform, he addressed the large crowd. Resting his hand on tattered battle flags, he reported for duty and paid homage to the lessons of war.

Rockville's street fairs, patriotic parades, and political rallies allowed townspeople a chance to relax, have fun, and share differing viewpoints on contemporary topics. But perhaps no other social event impacted the town as much as the Chautauqua movement of the early 20th century. The Chautauqua brought entertainment and culture to rural American communities with speakers, teachers, musicians, entertainers, preachers, and other personalities. Begun in 1911, the Rockville Chautauqua was no different. It quickly gained notoriety and drew large crowds. Notable speakers of the day included personalities such as politician William Jennings Bryan, Pres. William Howard Taft, and evangelist Billy Sunday. The era of the Chautauqua in Rockville lasted only 20 years with the last one being held in 1930. Competition from radio and movies, combined with a means of easy travel to other locations, allowed people to go to the entertainment rather than having it brought to them.

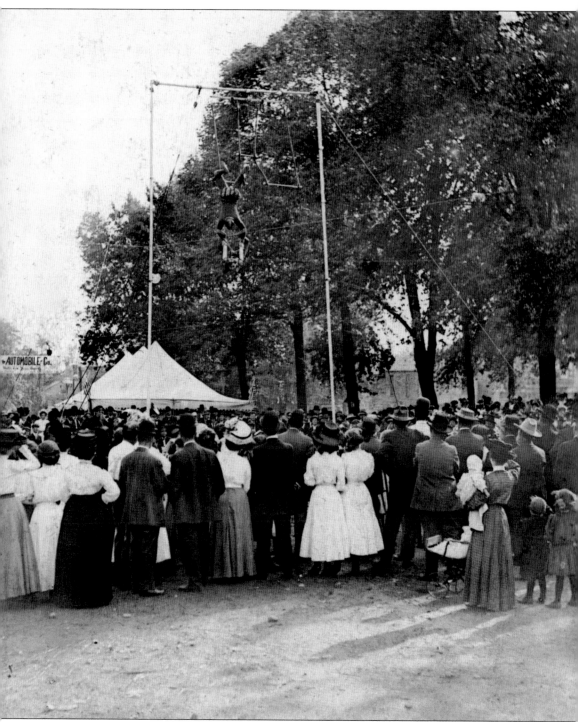

STREET FAIR PERFORMANCE, 1909. Acts such as this were popular during street fairs early in the century. This trapeze artist is performing in the middle of Jefferson Street on the east side of the square. Notice the banner in the background advertising the Rockville Harness, Buggy and Automobile Company. (Martin.)

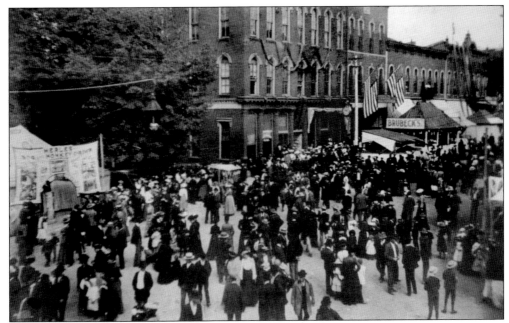

FIRST STREET FAIR, 1901. This photograph shows Rockville's first street fair in 1901. This view is looking from the Parke Hotel corner toward the old National Bank Building. Street Fairs were a popular fad during the first decade of the century. Eventually it was felt to be an impediment to the storeowners and shoppers trying to conduct day-to-day business, and they went out of style. (PCHS.)

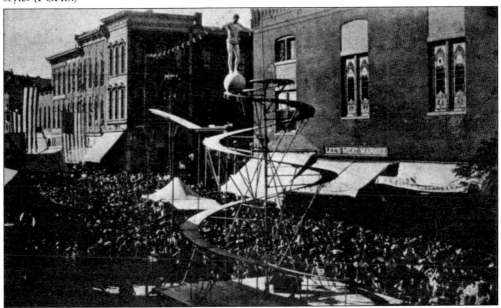

DAREDEVIL AT STREET FAIR, 1910. At a time without telephones, radios, or television, street fairs drew enormous crowds from around the county. This photograph shows a good view of the Opera House, with J. M. Ellett's Drug Store on the corner, and Lee's Meat Market next door. One can see where the original two-story Opera House windows were altered when the Masonic lodge moved into the building in 1907. (PCHS.)

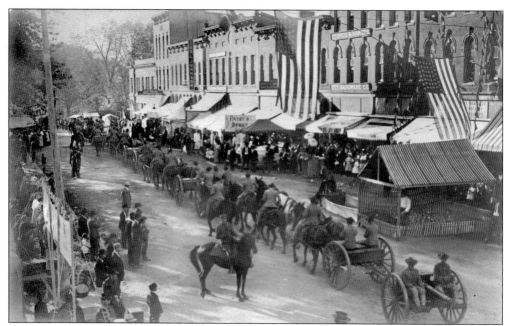

HOMECOMING PARADE, 1919. October 9, 1919, saw downtown Rockville come alive with a parade of returning veterans from World War I. The parade continued to Beechwood Park for a homecoming dinner and elaborate program in the Chautauqua auditorium. Out of an approximate population of 23,000 citizens, 1,057 had been called to service and 33 gave their lives. (Lyle.)

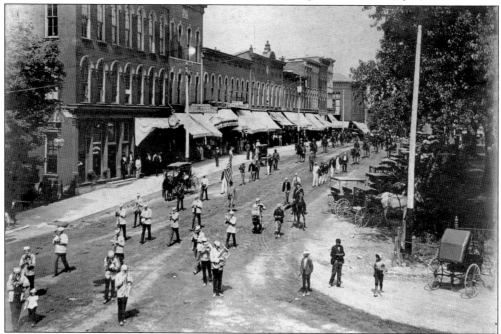

PATRIOTIC PARADE, C. 1892. At the turn of the century, brass bands were a very popular form of entertainment and nearly every town supported one. While most of the musicians were not musically trained, it was said that they were able to play old-time melodies to perfection. They are seen here leading what may be a Fourth of July parade. (PCHS.)

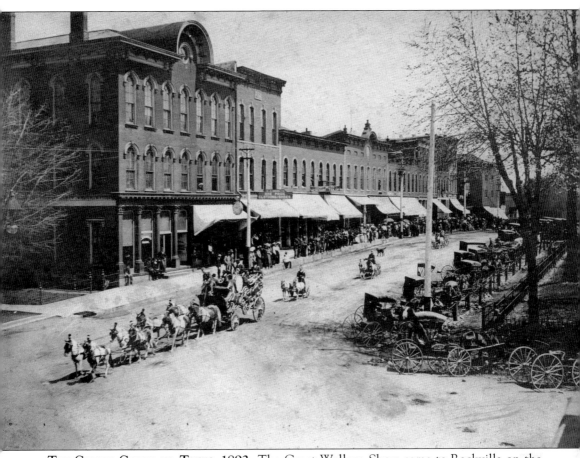

THE CIRCUS COMES TO TOWN, 1892. The Great Wallace Show came to Rockville on the morning of Wednesday, July 27, 1892. A crowd gathered to watch the performers as they headed west through town from the train depot to the old fairgrounds west of Yankee Street (now U.S. Route 41). (PCHS.)

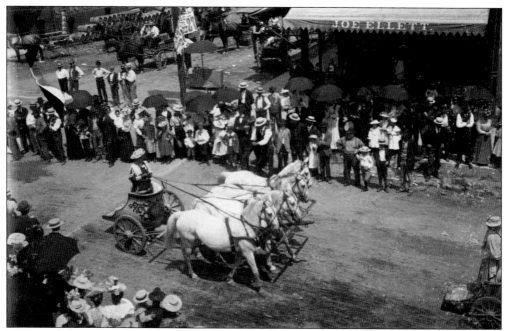

RETURNING TO THE VANDALIA DEPOT, THE GREAT WALLACE SHOW, 1892. A chariot from the Great Wallace Show is returning from the day's performance and heading east on Ohio Street towards Rohm's Roller Mill. There the animals rested and were given food and drink before being loaded back onto the train. (PCHS.)

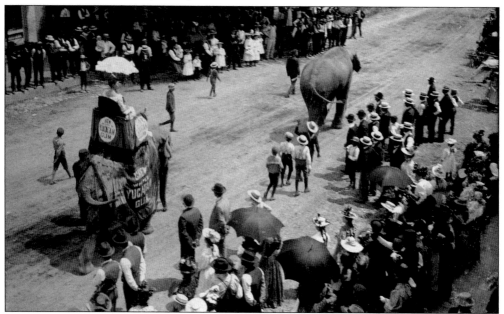

CIRCUS ELEPHANTS, THE GREAT WALLACE SHOW, 1892. The young lady with the parasol is riding an elephant sponsored by Yucatan Gum. Created in 1880, Yucatan was one of the first peppermint flavored chewing gums. The young men following the elephants must have been quite enthralled with the enormity of the creatures since many of them probably had not seen one before. (PCHS.)

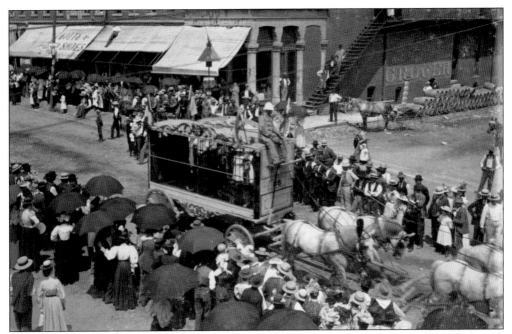

THE LEOPARD WAGON, THE GREAT WALLACE SHOW, 1892. Leopards are seen returning from their performance aboard the circus wagon. The spectacle of the parade appears to have drawn a large crowd. Many of the female onlookers were shielding themselves from the July sun with umbrellas. Note that many of the gentlemen still don their frock coats despite the heat. (PCHS.)

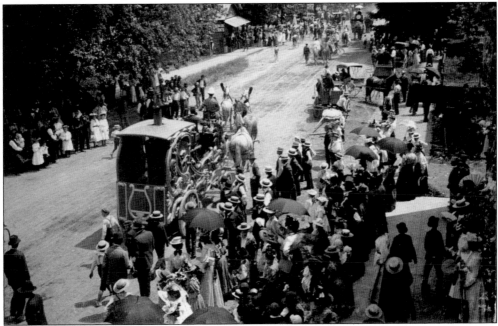

CIRCUS CALLIOPE, THE GREAT WALLACE SHOW, 1892. The circus calliope was traditionally the last participant of the parade. The calliope was an instrument that produced music by blowing steam through large whistles tuned to the chromatic scale. It was very loud and often could be heard for miles. (PCHS.)

STREET FAIR, 1901. Looking toward the Old National Bank Building from the balcony at the Parke Hotel, the tents and temporary booths remind one of today's Covered Bridge Festival. Merle's Dog and Monkey Circus can be seen in the center of Market Street next to the bank.

Tad Johnson, a clothier, had a booth in front of the Parke Hotel, and in the center to the left of the platform is a booth with what appears to be a snake exhibit. (PCHS.)

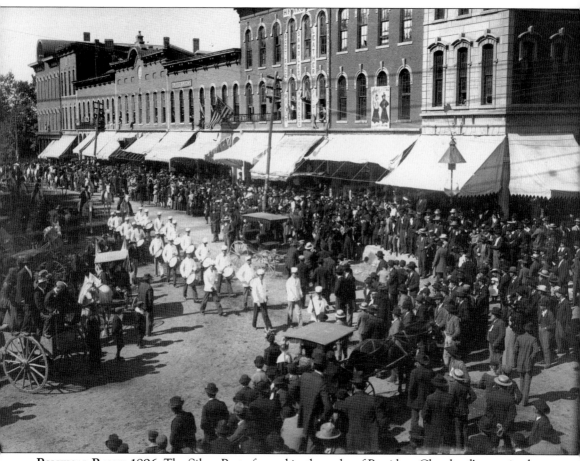

POLITICAL RALLY, 1896. The Silver Party formed in the wake of President Cleveland's perceived failed economic policy. The party's ideology was based upon the premise that a dollar backed by both silver and gold was better for the economics of the country. In Parke County, enthusiasm surrounding the issue abounded, and the Union Silver Party was formed, incorporating the Democrats, Populists, Prohibitionists, and Silver Republicans. (PCHS.)

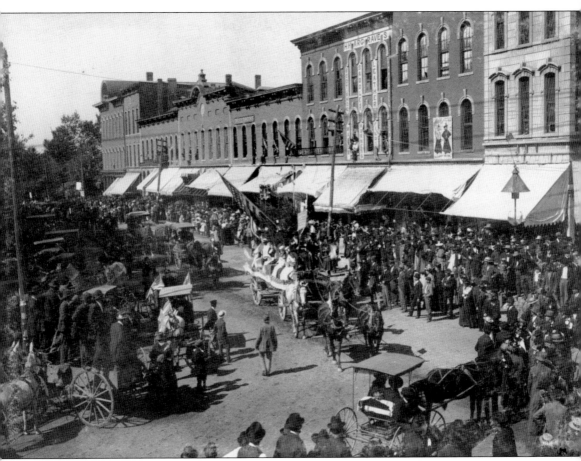

POLITICAL PARADE, 1896. The parade and political rally for the Union Silver Party was photographed here (and on the previous page) on October 3, 1896. It was thought to be the largest such political gathering in the history of the county. The party quickly faded into history as Republican William McKinley beat Democrat and Populist Williams Jennings Bryan in the 1896 presidential election. It is recorded that the parade was so large it took one hour and 50 minutes for it to pass. The Republicans held a rally two weeks later but it didn't approach the Silver Party's rally in either size or enthusiasm. (PCHS.)

BERT SHANE, C. 1919. Typical of the many tent shows that traveled the country before television, the Bert N. Shane Overland Show featured animal and magic performances along with a clown, a band, and aerial artists. The show was headquartered in Grand Rapids, Michigan, but spent several winters in Rockville. (PCHS.)

SHANE'S ANIMAL PERFORMERS, C. 1919. Scottish Collies named Spot, Dot, Tot and Joy, along with Bill the goat, were the star performers of the show. (PCHS.)

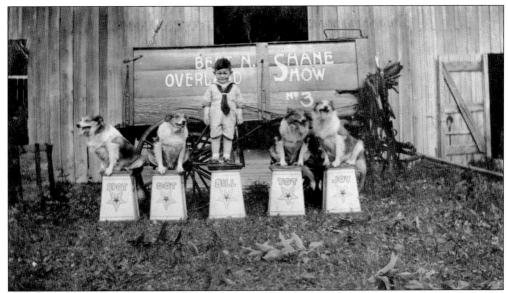

SHANE OVERLAND SHOW PRACTICE, C. 1919. Bert N. Shane made it his rule to allow any youngster into the show that he believed too poor to pay admission. This child who was taking Bill the goat's spot on the pedestal is thought to have been a member of Shane's family, possibly his son. (PCHS.)

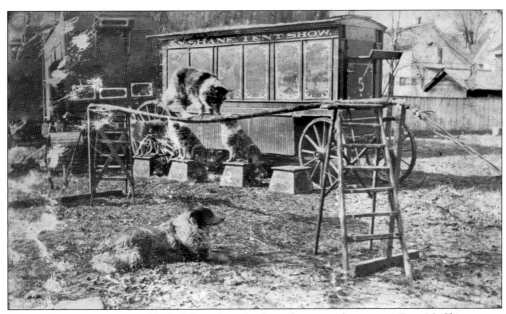

COLLIE PERFORMANCE, C. 1919. Other than its formal tent performances, Bert N. Shane gave smaller shows for audiences at places such as the county asylum, county infirmary, local lodges, and the town's many churches. (PCHS.)

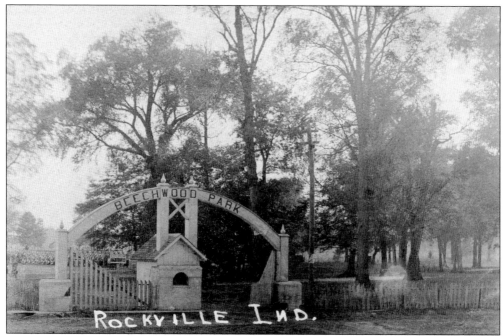

BEECHWOOD PARK ENTRANCE, 1909. In 1900, Rockville's first park was known as Noel Park. It was named after John L. Noel, who had donated 6 acres of land about five blocks north of the courthouse. The property had been used for years as the old baseball grounds but was devoid of any trees, making it a suitable park setting. Wallace McCune subsequently offered the town the area shown above, known as McCune's Grove. It was a longtime gathering place, totaling 15 acres southwest of town. (Martin.)

BEECHWOOD PARK, 1912. John L. Noel generously bought back his land from the town using the money toward the purchase of Wallace McCune's land. The new park was named Beechwood Park due to the number of large beech trees present on the property. This view shows how the entrance looked in 1909. One can see bleachers for the baseball field in the background; the Chautauqua auditorium wouldn't be built for another four years. (Martin.)

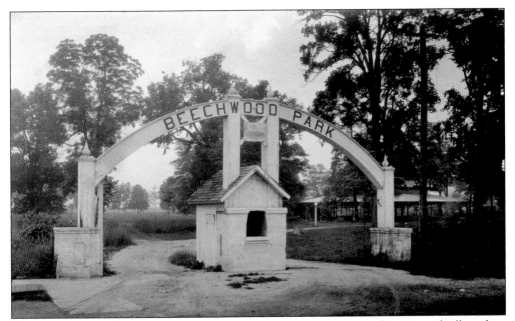

BEECHWOOD PARK ENTRANCE, 1920. The sign above the entrance reads, "No stock allowed on the park premises by order of the board—parties possessing stock subject to fine." Apparently roaming livestock was still a local problem as late as 1920. (Martin.)

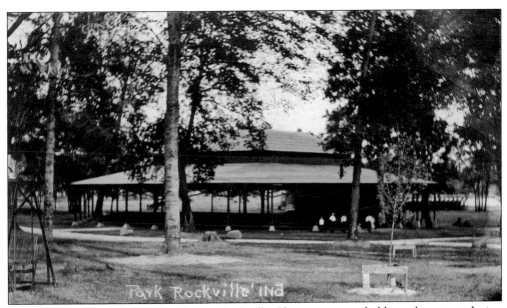

CHAUTAUQUA AUDITORIUM, 1915. The Rockville Chautauqua was held in a large tent during its first two years. In 1913, the large auditorium was constructed with a seating capacity of 3,600. (Martin.)

ROCKVILLE CHAUTAUQUA, 1913. The first Rockville Chautauqua was in the summer of 1911. The Chautauqua brought entertainment and culture to Rockville and the surrounding communities. For as many as 10 days, well-known speakers, preachers, scientists, musicians, and entertainers provided exposure to new ideas and the outside world. The rise of radio and ease of travel eventually brought the era to a close in 1930. (Martin.)

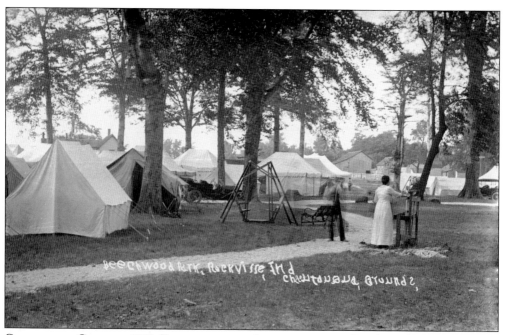

CHAUTAUQUA CAMPERS, 1913. Every year, a city of tents sprang up in Beechwood Park as hundreds of campers occupied the grounds during the Chautauqua festivities. Children played games and adults visited with friends and renewed old acquaintances. (Martin.)

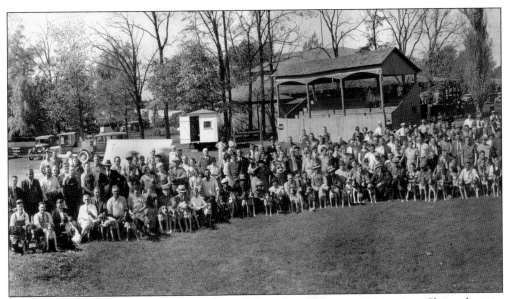

Fox Hunters, 1934. Over the years, the park has played host to many groups. Shown here in October 1934 is the Southern Indiana State Fox Hunters Association along with the Illinois Fox Hunter Association. They spent the entire week camped in the park with their prized animals. This is one of the few photographs that shows the old grandstand. (Martin.)

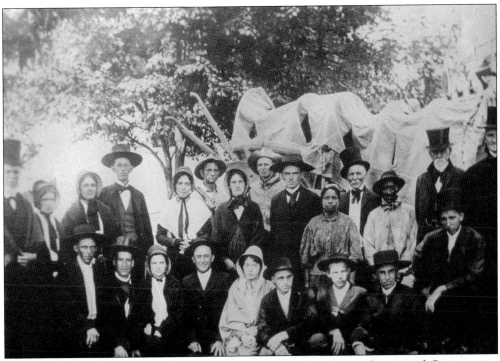

Centennial Pageant, 1916. These members of the Parke County Centennial Organization performed in a pageant at the Chautauqua on August 12, 1916, to commemorate the 100th anniversary of Parke County. The entire history of the county was presented, beginning with the coming of the French in 1706 and ending with the contemporary events of 1916. (PCHS.)

A Foggy Beechwood Park Morning, 1921. Shown here is a view of the Chautauqua auditorium and park lawn on a foggy morning in the summer of 1921. (Martin.)

Beechwood Park Fountain, 1913. With the building of the new auditorium in 1913 came many other improvements to the park. This fountain was located near the park entrance in the triangle formed by the intersection of Pennsylvania and College Streets. (Martin.)

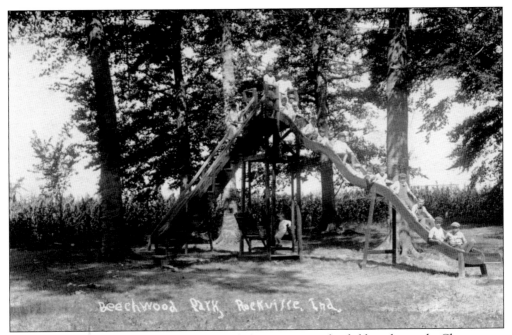

BEECHWOOD PARK SLIDE, 1913. Initially provided as amusement for children during the Chautauqua, the slide became a permanent and popular fixture in the park. (Martin.)

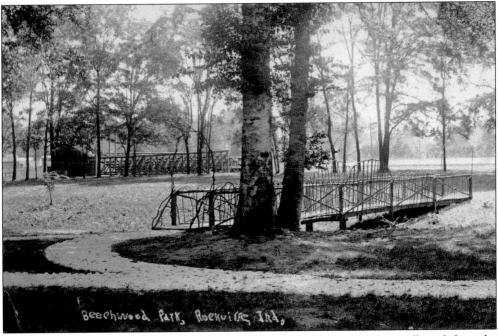

BEECHWOOD PARK FOOT BRIDGE, 1913. In 1913, the footbridge crossed the small creek from the main part of the park to the baseball grounds. (Martin.)

PARKE COUNTY INDEPENDENTS, 1908. Rockville saw its first baseball game played in 1872 and was home to a semiprofessional team from 1894 to 1896. The Independents played baseball at Beechwood Park. (PCHS.)

COUNTY CHAMPS, 1917. Sports, especially basketball, have always played an important part in the town's life. The 1917 Parke County champs are shown here in front of the old Rockville High School. They represent just one of the many championship teams Rockville has put on the court over the years. (PCHS.)

Six

A Town Matures
Rockville Adapts, 1946–1974

Imperceptible at first, the changes brought on by World War II irreversibly altered Rockville's character.

The end of the Great Depression and the war that followed brought a pent-up demand for goods. Now with good roads and the proliferation of the automobile, these goods could be purchased away from home. By mid-century, the spread of chain stores, with their larger selection of products and lower prices, heralded the beginning of the end for locally owned specialty stores. The future of these stores, which had been the backbone of the local economy for more than a century, was beginning to look uncertain.

By the 1970s, travel, buying, and work habits had changed. Lured by better access to jobs and careers, many young people pursued an education and moved away. Mom-and-pop businesses struggled to stay relevant. America was witnessing the dying struggle of the traditional American main street.

In 1974, two years before the nation's bicentennial, Rockville celebrated its 150th birthday. The photographs in this chapter document that unique time: a fast disappearing time when the public square was still a center of day-to-day commerce, and it looked much as it had a century earlier.

Within two decades after its 150th birthday, most of the remaining family businesses seen in these photographs—Clark's Regal Market, Insley's Drug Store, Smith's Clothing Store, Vic's Cut-Rate Clothing, the Corner Store, Criswell's Barber Shop, and the Parke Hotel—had closed. Murphy's Five and Dime still held a place of honor on the north side, as did Lee's Market and Overpeck's Hardware on the east side. Store by store, the local economy was gradually transitioning into an economy driven by tourism.

Thankfully, with the urban renewal movement of the previous decades having passed it by, the look of the town was still essentially unchanged. The nostalgic public square and picturesque covered bridges became a destination for those seeking to connect with their collective past.

Rockville's very future now lies in recapturing and sharing its rich heritage with others. May it continue down the road of preservation and rejuvenation that it has so successfully begun.

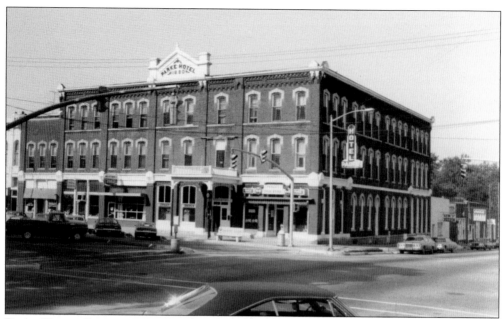

PARKE HOTEL CORNER, 1974. In 1974, the Parke Hotel remained much the same as it always was. Insley's Pharmacy anchored the corner and had enlarged into part of the old hotel lobby, where the barbershop and main desk were originally. The lobby desk was then moved to the top of the stairs on the second floor. Today the hotel is an apartment complex and the department of motor vehicles occupies the old drugstore corner. (Martin.)

FRYBERGER BUILDING, 1974. The old Fryberger Hardware and Appliance location was occupied by the Museum of Covered Bridges in 1974, and its appearance remains almost unchanged today. (Martin.)

CARSLISLE HUMPHERIES BLOCK, 1974. In 1974, Criswell's barbershop occupied the building to the left of the hotel that nearly a century earlier was Hungerford's. Lohrman Jeweler, Wilson Paints, and Clark's Regal Market occupy the 1894 Carlisle-Humpheries Block. Clark's was in the old Hargrave and McEwen's Furniture location, Wilson's in the old Kandy Kitchen location, and Lohrman's in the old Carlisle Grocery location. (Martin.)

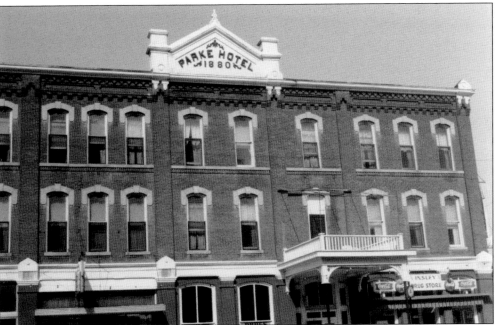

PARKE HOTEL, 1974. Tragically, the wonderful sign that adorned the top of the building, a Rockville icon, was destroyed during a violent storm in the late 1980s, as was the railing to the balcony above the hotel entrance. The courthouse lawn lost many of its large old trees as well during the same storm. (Martin.)

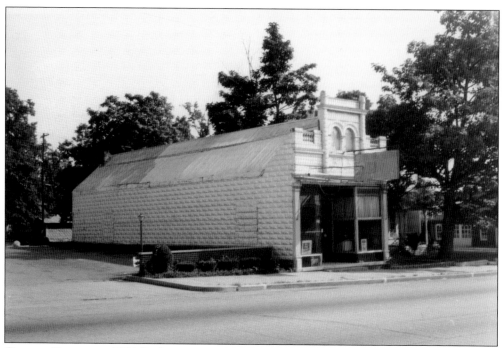

GAEBLER BUILDING, 1974. Built sometime prior to 1904, the Gaebler Building originally housed a monument sales company. Later it was home to a car dealership, laundromat, liquor store, and drugstore. It was moved to Billie Creek Village in 1982. (Martin.)

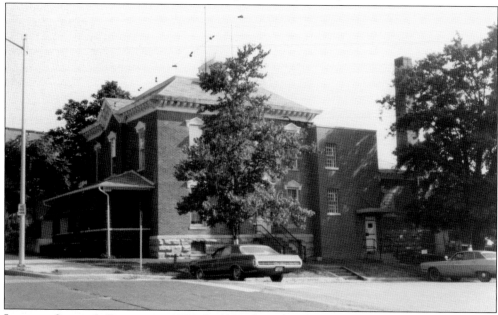

JAIL AND SHERIFF'S RESIDENCE, 1974. In 1974, the jail and sheriff's residence looked much the same as it had 75 years earlier. A front porch was added and the jail section was enlarged to accommodate more prisoners. Shortly after the date of this photograph, a fire swept through the structure causing a great deal of damage, especially to the rear. It was soon repaired and continued to operate as the jail for many more years. (Martin.)

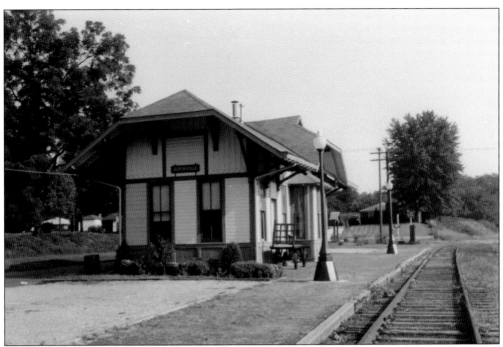

VANDALIA DEPOT, 1974. The old depot of the Vandalia Railroad was converted into a tourism center by Parke County Inc. in 1971. The station remains virtually unchanged today. (Martin.)

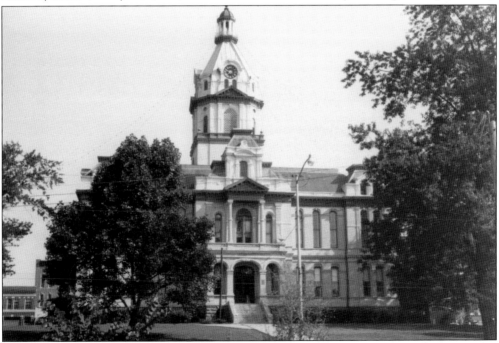

PARKE COUNTY COURTHOUSE, 1974. The courthouse has remained virtually unchanged since it opened its doors in 1882. The marble floors, ornate staircases, and handcrafted woodwork are still intact. Since October 1957, the courthouse lawn has proudly played host to the Parke County Covered Bridge Festival and its millions of visitors. (Martin.)

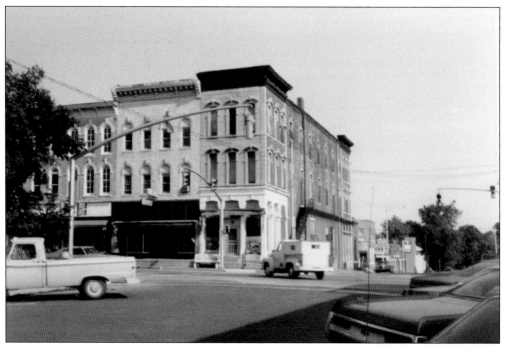

NORTHEAST CORNER OF THE SQUARE, 1974. In this 1974 photograph, the buildings composing the northeast corner of the square look relatively unchanged compared to photographs taken 75 years earlier. (Martin.)

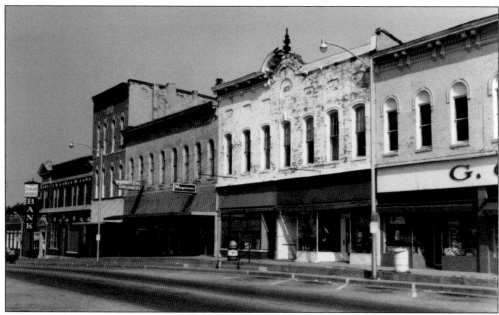

NORTH SIDE STORE FRONTS, 1974. At Rockville's 150th birthday celebration, the second floor facades of the north side buildings looked much like they did at the turn of the 19th century. The street level entrances have lost many of their original storefronts during modernization attempts over the years. Part of the arched cornice of the building in the center was lost to fire shortly before this photograph was taken. It has since been restored. (Martin.)

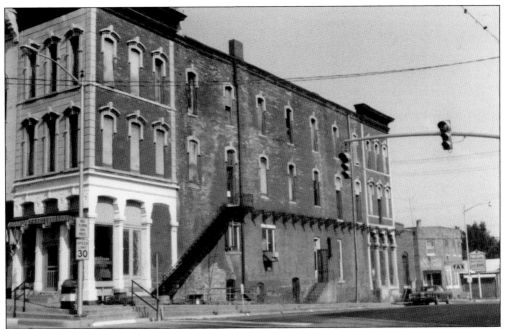

RICE AND COMPANY BUILDING, 1974. The Rice and Company Building was one of the first buildings constructed after the disastrous north side fire in 1874, and became the former home of Thomson and Sons Grocery. Sadly, this architectural cornerstone of the town was demolished in 2009 after many years of neglect allowed the masonry wall to fail on the east side. However, the front of the building was saved in place, and plans are underway for reconstruction of the rear part of the building. (Martin.)

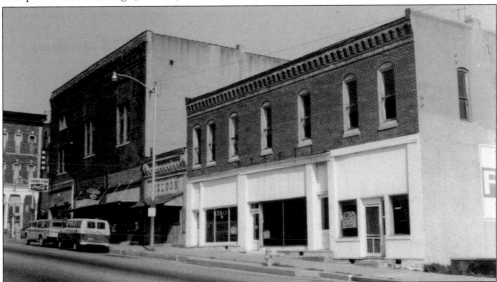

OLD OPERA HOUSE AND KELLY BLOCK, 1974. One of the oldest buildings remaining in town, the Opera House on the corner was dedicated in 1883. Sadly this building was also lost to neglect after its roof collapsed. The building was demolished in 2009, and the corner remains empty. The old Kelly Block to the right, built in 1891, along with the original one story saloon, was renovated and converted into a large tavern. (Martin.)

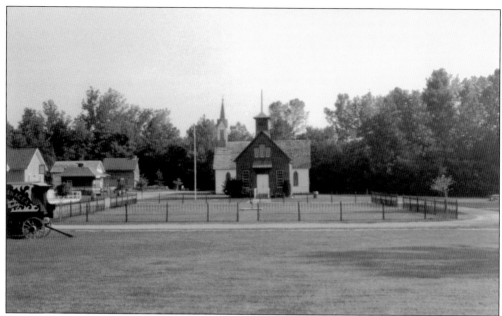

BILLIE CREEK VILLAGE SQUARE, 1974. In 1966, about 75 acres of land along William Creek was purchased with the intent of creating a turn of the century village and demonstrating the life of the period. Historic buildings from around the county, such as the one-room school from Lyford and the old 1886 Rockville Catholic Church, shown above, were moved to the location and carefully restored. The decorative iron fence used around the commons was originally around the courthouse square. (Martin.)

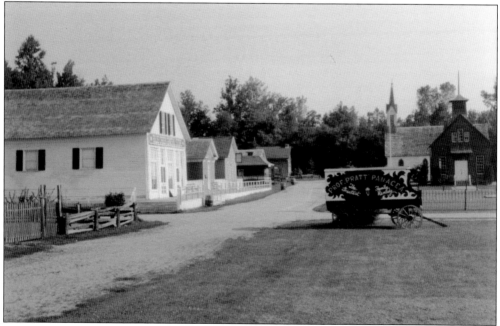

BILLIE CREEK VILLAGE STOREFRONTS, 1974. The general store building, originally from Annapolis, occupies a prime spot on the village square. The village is currently home to 38 period buildings and is open daily from Memorial Day through Labor Day. (Martin.)

BIBLIOGRAPHY

Atlas Map of Parke County, Indiana. Chicago, Illinois: A.T. Andreas, 1874.

Chautauqua Program Committee. *The Parke County Centennial Pageant Program.* Rockville, Indiana: The *Rockville Tribune,* 1916.

Issac P. Straus. *Historical Sketch of Parke County.* Rockville, Indiana: Rockville Chautauqua Association, 1916.

Juliet Snowdon. *The Parke County Courthouse.* Rockville, Indiana: Parke County Covered Bridge Museum, 1968.

Parke County Historical Society. History and Families of Parke County, Indiana. Paducah, Kentucky: Turner Publishing Company, 1989.

Parke Place Monthly Magazine, volumes 1-6. Rockville, Indiana: Torch Newspapers, Inc. 1981–1986.

Rockville Tribune Illustrated Souvenir and Historical Edition. Rockville, Indiana: the *Rockville Tribune,* 1896.

Rockville's Sesquicentennial Review. Rockville, Indiana: Torch Newspapers, Inc., 1974.

Standard Atlas of Parke County, Indiana. Chicago, Illinois: George A. Ogle and Company, 1908.

www.arcadiapublishing.com

Discover books about the town where you grew up, the cities where your friends and families live, the town where your parents met, or even that retirement spot you've been dreaming about. Our Web site provides history lovers with exclusive deals, advanced notification about new titles, e-mail alerts of author events, and much more.

MADE IN THE USA

Arcadia Publishing, the leading local history publisher in the United States, is committed to making history accessible and meaningful through publishing books that celebrate and preserve the heritage of America's people and places. Consistent with our mission to preserve history on a local level, this book was printed in South Carolina on American-made paper and manufactured entirely in the United States.

This book carries the accredited Forest Stewardship Council (FSC) label and is printed on 100 percent FSC-certified paper. Products carrying the FSC label are independently certified to assure consumers that they come from forests that are managed to meet the social, economic, and ecological needs of present and future generations.

FSC
Mixed Sources
Product group from well-managed
forests and other controlled sources

Cert no. SW-COC-001530
www.fsc.org
© 1996 Forest Stewardship Council

Find Your Place in History.